MW00584323

HISTORIC BUILDINGS OF DOWNTOWN CARMEL-BY-THE-SEA

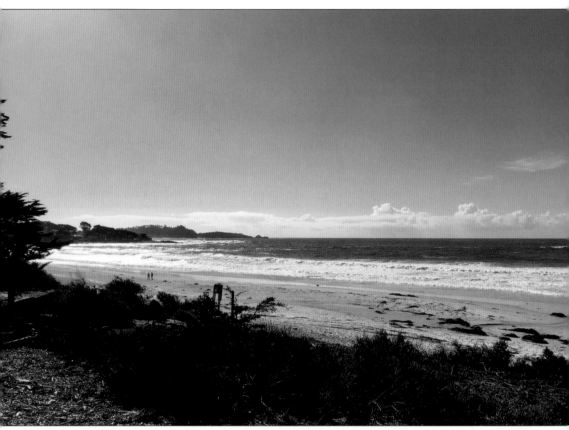

CARMEL BEACH. This world-renowned white sandy beach makes Carmel-by-the-Sea one of the most beautiful places. *National Geographic Traveler* calls it "One of America's Best Beach Towns," *Condé Nast Traveler* readers named it No. 2 "Best Small City in the U.S.," and *Travel + Leisure* ranks Carmel as the No. 3 "Best City for Romance in the World." (Author's collection.)

HISTORIC BUILDINGS OF DOWNTOWN CARMEL-BY-THE-SEA

Alissandra Dramov

ARCADIA
PUBLISHING

Published by Arcadia Publishing
Charleston, South Carolina

Printed in the United States of America

Library of Congress Control Number: 2018955607

For all general information, please contact Arcadia Publishing:
Telephone 843-853-2070
Fax 843-853-0044
E-mail sales@arcadiapublishing.com
For customer service and orders:
Toll-Free 1-888-313-2665

Visit us on the Internet at www.arcadiapublishing.com

To Jon Konigshofer,
You were a star in your time and still deserve to shine.

CONTENTS

ACKNOWLEDGMENTS

To be designated as historic, a building must be at least 50 years old with a significant designer/builder and/or a notable owner/occupant. Whenever possible, names of original owners who commissioned the structures are referenced and the building's historical name is used. The book predominately features buildings listed in Carmel-by-the-Sea's Historic Resources Inventory. A few additional ones not in the inventory are included, as they are longtime local establishments with ongoing significance.

There are no street numbers in Carmel-by-the-Sea proper, so addresses are given geographically based on the intersection of two streets. The number in front of the direction refers to how many lots the property is away from the intersection.

Thank you to Katie O'Connell, Local History Librarian at Harrison Memorial Library, and the Carmel Building and Planning Department and Monterey Public Library. I would like to thank these members of the community for their continued support: Carmel-by-the-Sea mayor pro tem Carrie Theis; mayor Steve Dallas; Barney Scollan, owner of Carmel Bay Company; Mary Crowe, general manager of La Playa Hotel; and Ross Arnold, owner of Carmel Drug Store.

Lastly, I would like to acknowledge the legacy of pioneering Northern California historic preservationist—and the first woman in California to earn a contractor's license—Enid Thompson Sales (1922–2008), who spent the last two decades of her life in Carmel-by-the-Sea, where she documented and fought to save the town's architecturally significant historic structures. She had a vision to see a downtown historic district created in Carmel, which did not happen during her lifetime.

All photographs are courtesy of the author.

INTRODUCTION

Carmel-by-the-Sea began in the early 20th century as an artists' and writers' colony on the Pacific Coast about 120 miles south of San Francisco. It covers one square mile. Many of the earliest residents were visitors, often from the Bay Area, who came during the summer; the population was then in the hundreds. The downtown business district contained a handful of stores along the main street, Ocean Avenue, that provided essentials to residents. A small number of pioneering families became major landholders downtown; their properties were passed along to their descendants, and some still remain owners of those properties to this day. In the 1920s, there were more year-round residents in Carmel-by-the-Sea, such as retirees, along with seasonal visitors, many of whom were wealthier. At this time of economic growth, development, and expansion, the town's architectural character took shape: buildings were commissioned and more businesses were established downtown. The stretch of Dolores Street between Ocean and Seventh Avenues became the downtown's center: the city hall, post office, police station, newspaper office, bank, dry cleaner, grocery, meat market, bakery, pharmacy, and other establishments provided for residents' needs. After World War II, during the postwar economic boom, the town's population grew to its all-time highest number—nearly 5,000. Carmel-by-the-Sea became a tourist town, with a shift away from businesses that served locals and instead to those that catered to the expanding tourist trade. The main commercial thoroughfare remained on both sides of Ocean Avenue; there was a great increase in hotels, restaurants, gift shops, art galleries, real estate offices, and other retailers.

In the early 1900s, when Carmel-by-the-Sea was founded, the first downtown buildings were generally made of wood, and mostly in the Western false front style, along with some Victorian and Craftsman designs, but very few of these original buildings remain. The now-familiar look of the town as a quaint European village was shaped in the 1920s and 1930s, when the downtown as today's residents know it was developed mainly through the Romantic European Revival styles: Tudor and Spanish Revival (or Spanish Eclectic). These mirrored the influential national trends during the Roaring Twenties and Great Depression and were the dominant architectural styles of the time. Though Tudor and Spanish Revival styles were predominant, some other period styles could also be found downtown. The Fairy Tale (or Storybook) substyle of Tudor Revival architecture present in other parts of California in the 1920s was developed locally by builder Hugh Comstock; he created the Tuck Box restaurant, with its undulating roof lines and wavy brick chimney, on Dolores Street in 1926.

Northern European, Old World, and medieval architectural influence first arrived downtown with theater impresario Edward Kuster, who designed the Court of the Golden Bough to resemble an European village in the early-to-mid-1920s. The Tudor Revival–style buildings, which surrounded the flagstone courtyard, had thatched roofs, turrets, and half-timbering architectural features reminiscent of medieval architecture. The main grouping of these building designs can be found in the area of Ocean Avenue and Monte Verde Street. Three of the larger Tudor Revival–style buildings downtown are the De Yoe Building (1924) on Dolores Street, the Seven Arts Building (1925) on Ocean Avenue and Lincoln Street, and the former Sunset School (1925) on San Carlos Street and Ninth Avenue.

Southern European and Mediterranean architectural influence is evident in the Spanish Revival (or Spanish Eclectic) style of the main commercial buildings at the heart of downtown along both sides of Ocean Avenue, such as the Doud Building (1932), Reardon Building (1932), Goold Building (1932), and Las Tiendas (1930). A majority of these were the work of local builders, such as M.J. Murphy, who modeled the structures using the design styles and techniques of California architects. These are all large, two-story mixed-use buildings made of white stucco exterior and red tile roofs, often with second-story balconies. Las Tiendas, designed by architects Swartz & Ryland, had a tile passageway and courtyard.

The greatest concentration of the best examples of Spanish Revival–style buildings can be found on Seventh Avenue between Lincoln and Dolores Streets in three significant buildings done by Oakland architects David Blaine and Roger Olson: La Giralda (1927), El Paseo (1928), and Hotel La Ribera (Cypress Inn) (1929). Blaine and Olson had traveled to Spain, studied Spanish architecture firsthand, and constructed all three of these impressive buildings in harmony to resemble a Spanish Hill town. They featured traditional, architectural details of Spain such as handmade colorful tilework, hand-carved woodwork, and decorative wrought ironwork. Blaine and Olson were known for their Spanish Colonial Revival designs in Santa Barbara after the 1925 earthquake, and they were part of the leading California architectural firm that did work in downtown Carmel during this period, with a total of five buildings designed in this style in the late 1920s.

Blaine and Olson fully remodeled the Pine Inn in 1928 in the Spanish Eclectic style, and in 1941, designer Jon Konigshofer expanded the hotel's property with his addition of a dozen courtyard shops in a garden setting designed by prominent Bay Area landscape architect Thomas Church. Through the 1940s and 1950s, Church contributed to Carmel-by-the-Sea's outdoor look residentially and commercially, including in Ocean Avenue's landscape median design. In the early 1940s, Konigshofer significantly enlarged La Playa Hotel, another of the town's oldest and most distinguished hotels, also in the Spanish Eclectic style.

Some modernism began to appear downtown from the middle of the 20th century onward in designs by local architects Robert Jones, Walter Burde, Will Shaw, and Olof Dahlstrand. They used Second and Third Bay Region styles and Organic architecture influenced by Frank Lloyd Wright. Some of these post–World War II contemporary designs can be found in several churches, banks, and other downtown buildings.

From its earliest days, Carmel-by-the-Sea has emphasized the outdoors, nature, and walking. There are dozens of courtyards and passageways in and between downtown buildings, often paved with tile, flagstone, or brick, which contribute to the quaint character of the town and remind people of Europe. Outdoor fountains, plants, flowers, and flowerpots add to the charm. Parks, gardens, sidewalks, and the Ocean Avenue median are landscaped with many trees, making Carmel-by-the-Sea a village-in-a-forest.

In July 2018, *Architectural Digest* described Carmel as stunning and named it the prettiest town in California. Carmel-by-the-Sea's historic architecture gives the downtown area an appearance similar to that of an Old World European village. Although they may have been altered, many of the Romantic Tudor and Spanish Revival buildings that established the look of downtown in the 1920s and 1930s remain a major presence to this day. With its seaside setting and beautiful natural scenery, along with its historic downtown architecture, Carmel-by-the-Sea is a picturesque, one-of-a-kind town unlike anyplace else.

One

CITY-OWNED PROPERTIES AND NONPROFITS

OCEAN AVENUE LANDSCAPE MEDIAN. Ocean Avenue is the main street through the center of downtown Carmel-by-the-Sea. In the early 1940s, the city removed parking along its median from Junipero Street to Monte Verde Street. Widely-regarded San Francisco-based landscape architect Thomas D. Church (1902–1978) designed the stone landscape median with plants and shrubs.

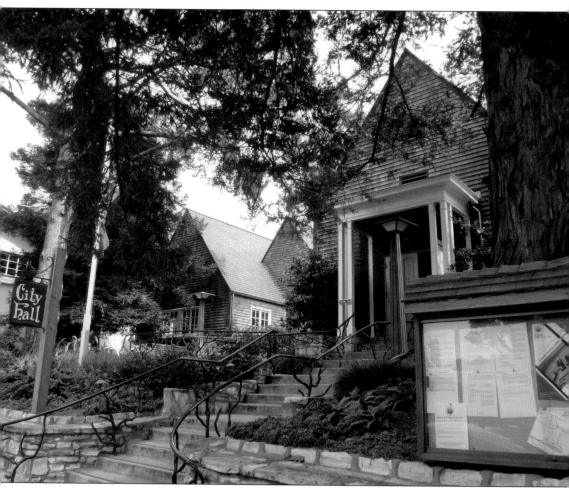

CARMEL CITY HALL. This Craftsman-style, wood-shingled building with a steep-pitched gable roof was constructed in 1913 as an Episcopal church on Monte Verde Street 3NE of Seventh Avenue. The structure was designed by San Francisco architect Albert Cauldwell and built by Michael J. ("M.J.") Murphy (1885–1959). In 1946, the city bought it as the new city hall—Carmel's third (and current) city hall. In a 1953 major remodel, architect George Wilcox removed the bell tower and put in a flat-roofed classical portico entry to the council chambers, making it look less church-like. A parking lot was added in 1956. City Hall was remodeled in 1973 by noted Bay Area architect Albert Henry Hill (1913–1984), a Carmel resident, and in 1985 by local architects Fred Keeble and George Rhoda, the year before actor and director Clint Eastwood (b. 1930) was elected mayor.

CITY HALL GARDEN. The Carmel-by-the-Sea Garden Club undertook the restoration of the Carmel City Hall's garden in 2012. It was named in memory of member Constance Meach Ridder (1941–2011). In 2015, the garden was added to the Smithsonian Institution's Archives of American Gardens.

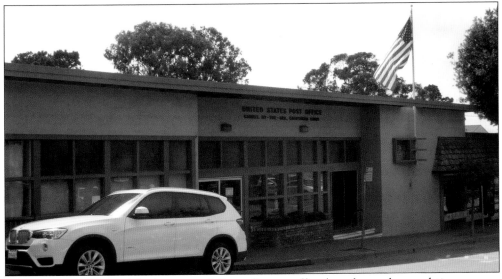

CARMEL POST OFFICE. The location of Carmel's post office has changed several times over a century. This current building, located on Fifth Avenue 2SE of Dolores Street, has been the site since the 1950s and was expanded in the early 1960s. Since there is no home delivery of mail, from Carmel's earliest days, the post office has served as a central meeting place for Carmel residents to pick up their mail, packages, and daily gossip.

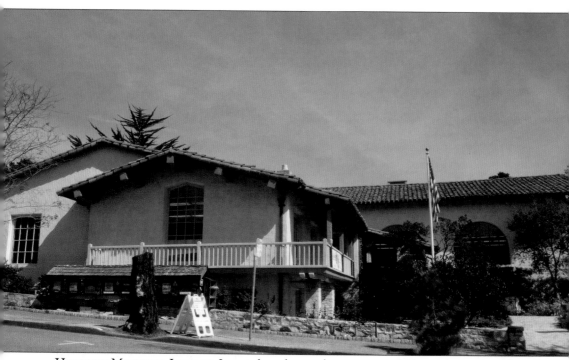

HARRISON MEMORIAL LIBRARY. Located on the northeast corner of Ocean Avenue and Lincoln Street, the Spanish Eclectic–style building was designed and constructed by M.J. Murphy with prominent Bay Area architect Bernard Maybeck (1862–1957) as supervising architect. It has a red tile roof, stucco exterior walls, a Monterey Colonial–style balcony, and Carmel stone (flagstone) veneer and retaining walls. It was built in honor of California Supreme Court Justice Ralph Chandler Harrison as a bequest from his widow, Ella Reid Harrison, and opened in 1928. Previously, the Carmel Free Library Association, which began in 1905, operated in a nearby redwood-shingled cottage through 1927. Architect Robert Jones made design changes in 1949 and 1976 remodels. Artworks by Remo Scardigli (1910–1984) and John O'Shea (1876–1956) are displayed inside.

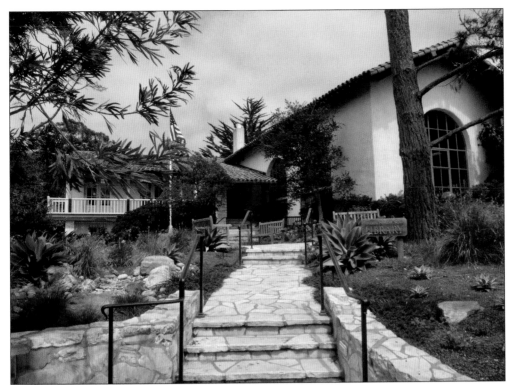

HARRISON MEMORIAL LIBRARY GARDEN. In 2004 and 2005, noted Bay Area landscape architect Walter V. Guthrie (1932–2006), who had worked for Thomas Church, did the landscape design for this garden. It now features native and drought-tolerant plants. Carmel-by-the-Sea Garden Club volunteers provide additional upkeep.

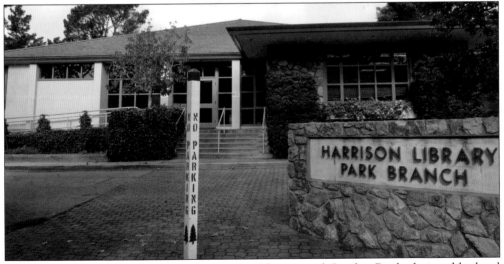

HARRISON MEMORIAL LIBRARY PARK BRANCH. The original Crocker Bank, designed by local architect Olof Dahlstrand (1916–2014) in 1965 on the northeast corner of Mission Street and Sixth Avenue, was converted to a library annex in 1989, a decision from mayor Clint Eastwood's term. Architect William Foster repurposed the interior to house the Henry Meade Williams Local History Department; the former bank vault now holds old manuscripts and photographs.

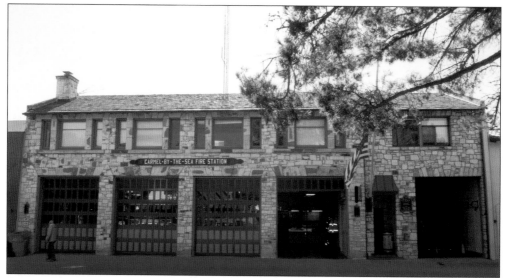

CARMEL FIRE STATION. The two-story firehouse with a flagstone facade was designed by architect Milton Latham and built by M.J. Murphy in 1936–1937 on Sixth Avenue 2NE of Mission Street, paid for through federal WPA funds and a city bond. Well-known blacksmith Francis Whitaker (1906–1999) did the ironwork for the engine bay doors. In 1974, architects Thomas S. Elston Jr. (1912–1992) and William Lyle Cranston (1918–1986) designed a fifth engine bay addition.

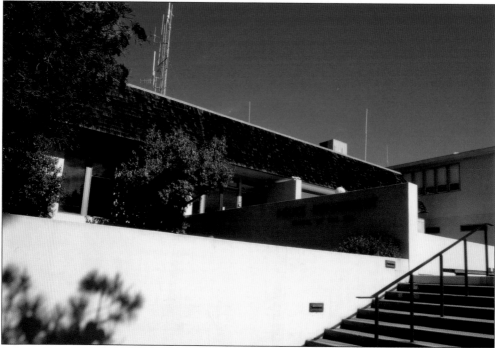

CARMEL POLICE STATION. In 1966, architects Will Shaw (1924–1997) and Walter Burde (1912–1996) designed this building with a mansard roof on the southeast corner of Junipero Street and Fourth Avenue and the adjacent Public Works to mark the city's 50th year of incorporation. A new city hall was planned as part of a civic center complex, but neither was built. There are future renovation plans.

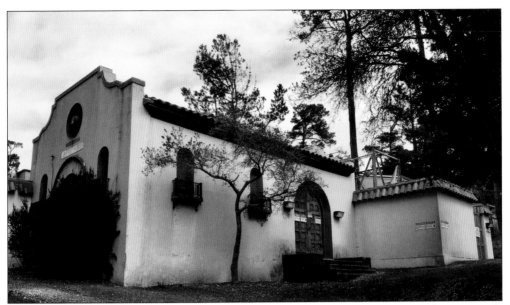

COAST VALLEYS GAS & ELECTRIC SUBSTATION (PG&E). The one-story Spanish Eclectic–style public utility building on the northeast corner of Junipero Street and Second Avenue was built in 1926. A high stucco wall with mission tile caps was added in 1969 along the corporation yard. Electricity was established in Carmel in the 1910s; gas service began in the 1930s.

PACIFIC TELEPHONE AND TELEGRAPH CO. BUILDING (AT&T). The telephone exchange building was constructed on the southwest corner of Junipero Street and Seventh Avenue in 1949 to house dial telephone equipment. In 1950, Carmel was the last city on the Monterey Peninsula to transition to dial phones.

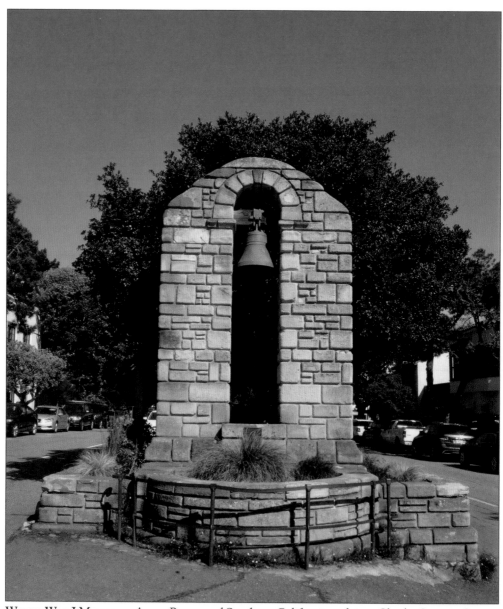

WORLD WAR I MEMORIAL ARCH. Renowned Southern California architect Charles Sumner Greene (1868–1957), known for his Arts and Crafts–style houses, moved to Carmel in 1916. He designed the Spanish Mission Revival–style flagstone memorial at the Ocean Avenue and San Carlos Street center median divider. The arch was constructed by stonemason Joseph McEldowney; dedicated on November 11, 1921; and maintained by American Legion Post 512. In 1966, to mark the city's 50th anniversary, Harry J. Downie (1903–1980), who spent decades restoring the Carmel Mission, donated the first Spanish-style bell. Every Memorial Day and Veterans Day, an American Legion Post 512 member rings the bell at 11:00 a.m. The memorial was one of 100 across the country chosen by the United States World War I Centennial Commission to receive a matching federal grant for stone restoration work, for the 100th anniversary of the end of World War I.

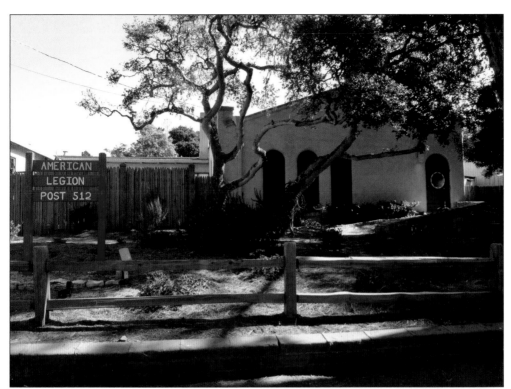

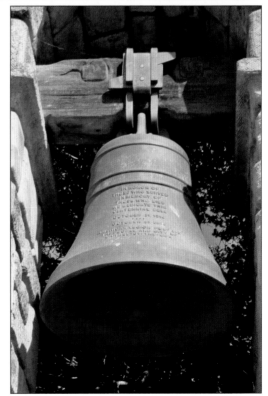

AMERICAN LEGION POST 512 BUILDING (ABOVE) AND WORLD WAR I MEMORIAL BELL, 2016 (RIGHT). In 1926, World War I veteran Guy O. Koepp designed and M.J. Murphy built the Spanish Eclectic–style building on Dolores Street 2SE of Eighth Avenue as the Manzanita Clubhouse, Carmel's men's social club. The building became the headquarters for the American Legion Post 512 in 1935. During World War II, it was a USO station for military members on their way to the Pacific Theater. American Legion Post 512 raised $10,000 for a new commemorative bell in Charles Greene's original design for the World War I Memorial Arch. It was installed on October 31, 2016, marking the city's centennial anniversary of incorporation.

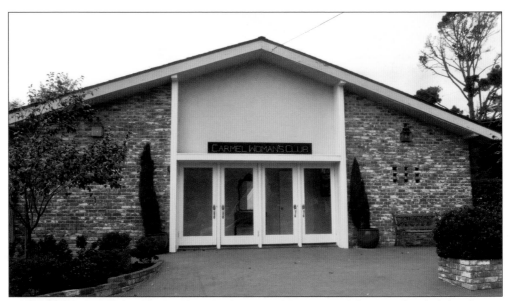

CARMEL WOMAN'S CLUB. The building for the Carmel Woman's Club, a social and philanthropic organization that began in 1925, was designed in 1946 by architect Thomas Elston and constructed by the Stolte Company on the southwest corner of San Carlos Street and Ninth Avenue. In the 1980s, when Clint Eastwood was mayor, city council meetings were moved here to hold the larger crowds.

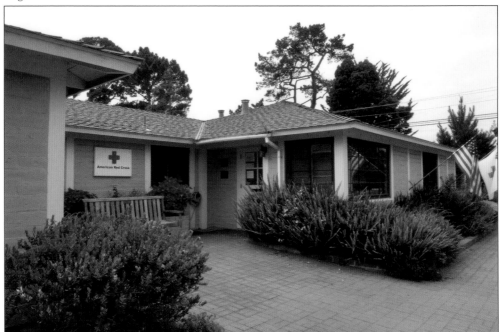

CARMEL RED CROSS. The Monterey Bay Area Chapter of the American Red Cross of the Central Coast has been at this one-story building on the southeast corner of Dolores Street and Eighth Avenue since 1955. President of Comstock Associates, architect James B. Pruitt (1912–1986), designed it using the Post-Adobe building method, consisting of waterproof bricks made of emulsified asphalt, developed by local builder Hugh W. Comstock (1893–1950).

SCOUT HOUSE. M.J. Murphy constructed this Craftsman-style building for local Boy Scout Troop 86 in 1931 on the northeast corner of Mission Street and Eighth Avenue. Purchased by the city as a community center, it closed for a decade in the early 2000s for needed repairs. From 2014 through 2016, a local scout refurbished the structure and driveway—making it compliant with the Americans with Disabilities Act (ADA)—to earn his Eagle Scout badge.

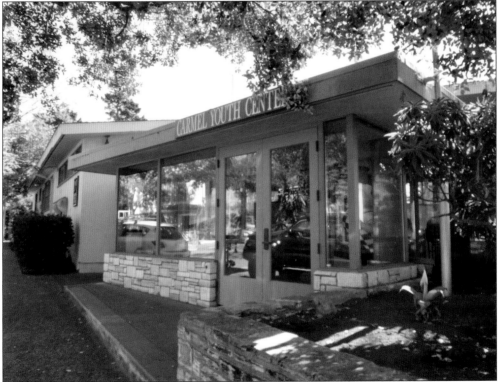

CARMEL YOUTH CENTER. Entertainer and philanthropist Bing Crosby (1903–1977), who founded his namesake Pro-Am Golf Tournament in neighboring Pebble Beach in 1947, established the privately-funded nonprofit youth center in 1949; it is now the only one of 200 still open in the country. Architect Robert R. Jones (1911–1989) designed it on Fourth Avenue 2SW of Torres Street. Crosby, whose Pebble Beach home was designed by Jon Konigshofer (1906–1990), attended the 1950 opening of the center.

FIRST MURPHY HOUSE. The vernacular cottage, which has undergone numerous alterations, was built by M.J. Murphy in 1902 for his mother. Saved from demolition in 1990 and moved by crane to this location on Lincoln Street 2NW of Sixth Avenue, it is now a city-owned community center used by the Carmel Heritage Society.

MILK SHRINE. This is one of the last remaining examples of the Craftsman-style wood-shingled structures with shelves for milk delivery; these were a common sight in residential Carmel during the 1920s and 1930s. It is now located outside the First Murphy House.

Two

PARKS

PICCADILLY PARK. The pocket park was established in 1998 on Dolores Street 6NW of Seventh Avenue after the city purchased the longstanding Piccadilly Nursery in the early 1980s, keeping the land as open space. Landscape architect Walter Guthrie designed the original landscaping. There are public restrooms at the back of the park.

DEVENDORF PARK. The entire city block bordered by Junipero Street, Mission Street, Ocean Avenue, and Sixth Avenue at the town's entrance was purchased by the city in 1922. It became a city park in 1930 and was named for Carmel-by-the-Sea's co-founder, Frank Devendorf, and landscaped by 1932. Several times before World War II, the land was considered for a potential civic center site. In 1941, designer Jon Konigshofer's plans for a two-story Monterey Colonial–style

city hall facing Sixth Avenue, along with Thomas Church's landscaping, were showcased on the front page of the *Monterey Peninsula Herald*. Ultimately, the park remained an open public space, a site for civic gatherings—but no dogs are allowed. The large, coast live oak tree in the southwest corner, "The Patriarch," is possibly the largest such tree in the village.

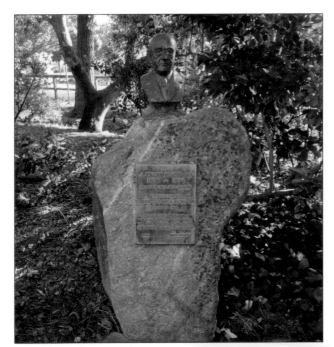

FRANK DEVENDORF BUST. Real estate developer James Franklin Devendorf (1856–1934) and attorney Frank Hubbard Powers (1864–1920) founded the Carmel Development Company in 1902, establishing Carmel-by-the-Sea in 1903. In 1949, a bronze bust of Devendorf, "the father of Carmel," was created by his daughter Edwina Dupre Devendorf (1881–1954), a California artist and sculptor, and dedicated in the park.

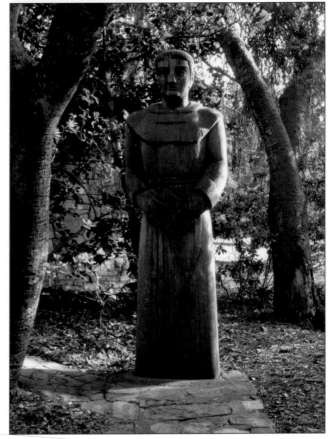

FR. JUNÍPERO SERRA STATUE. The redwood carving of Father (now Saint) Junípero Serra (1713–1784) in Devendorf Park was made in 1937 as part of a WPA project by Italian-born artist and sculptor Remo Scardigli. In the 1950s, he designed and built a house in Carmel for himself and his artist wife, Evelyn.

WORLD WAR II MEMORIAL. There are war memorial markers for World War II, the Korean and Vietnam Wars, and 9/11 throughout Devendorf Park, all placed by American Legion Post 512. The granite boulder with a bronze plaque inscription below the flagpole memorializes the 20 Carmel servicemen who died in World War II.

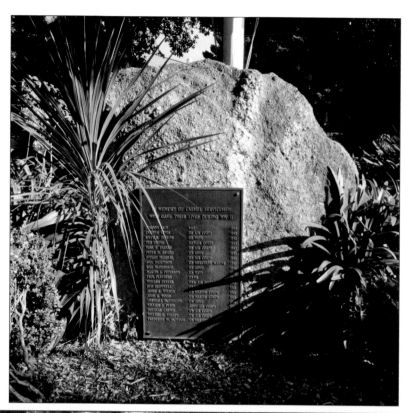

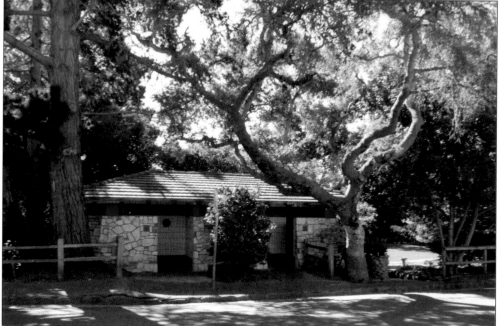

DEVENDORF PARK RESTROOMS. During Clint Eastwood's mayoral term, from 1986 to 1988, public restrooms were added to the northeast corner of Devendorf Park on the Sixth Avenue side. The Carmel stone veneer facility complements the low Carmel stone border walls surrounding the park.

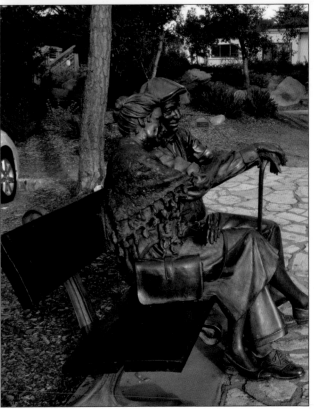

FIRST MURPHY PARK (ABOVE)
AND *THE VALENTINE* (LEFT). A
city park was built surrounding
part of First Murphy House on
the northwest corner of Lincoln
Street and Sixth Avenue after
it was moved there in 1990. A
commemorative wood bench
honoring California historic
preservationist Enid Sales,
who helped save First Murphy
House, was added in 2013.
Public restrooms are below the
upper wooden deck of the park.
This bronze figure-grouping
sculpture by Colorado-based
sculptor George W. Lundeen
(b. 1948), which was purchased
by the city and placed in the
southeast corner of the park
in 1994, is a popular site for
tourists to take photographs.

Three

CHURCHES

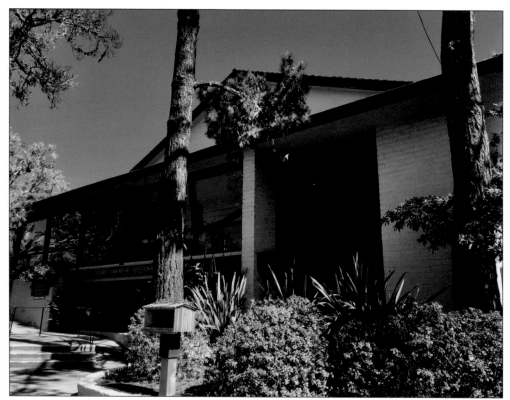

FIRST CHURCH OF CHRIST, SCIENTIST. Architect Walter Burde designed the contemporary church with Second Bay Region–style elements on Monte Verde Street 2NE of Sixth Avenue in 1950. It was one of several places of worship on the Monterey Peninsula that he designed during his career.

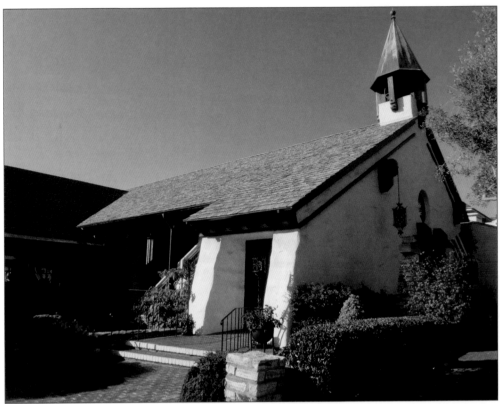

CHURCH OF THE WAYFARER (ABOVE) AND MASTER'S GARDEN (BELOW). The original Methodist church was built in 1905 on the northwest corner of Lincoln Street and Seventh Avenue. In 1940, architect Robert Stanton (1900–1983) designed this new church, renamed the Church of the Wayfarer, at the site. The garden, formerly known as the Biblical Garden, is said to contain plants mentioned in the bible and is a venue for outdoor weddings. In 1947, Hollywood actress Kathryn Grayson married singer Johnnie Johnson at the church. In recent years, an old tradition has been brought back: community members ring the church bells 12 times at noon everyday.

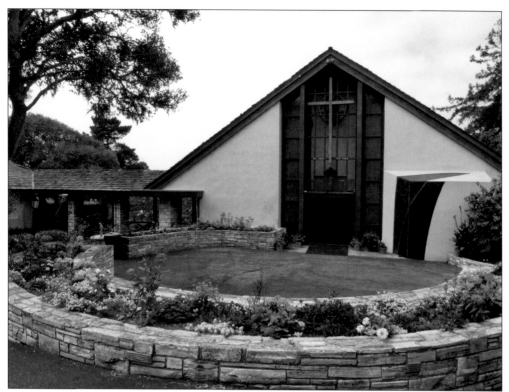

ALL SAINTS' EPISCOPAL CHURCH (ABOVE) AND GARDEN TERRACE (BELOW). After the first All Saints' Episcopal Church was sold in 1946 to be used as the new city hall, a replacement church was designed on the southwest corner of Dolores Street and Ninth Avenue by modernist architect Robert Jones. The terrace and patio were done by Bay Area landscape architect Thomas Church. It opened in 1951, and the following year, *Architect and Engineer* magazine featured the church of Carmel stone and redwood for its design, which displayed a mix of traditional and modern elements. In 1960, an auditorium was added by Jones. The church was visible in the 1959 movie *A Summer Place*, which was filmed at various Monterey Peninsula locations.

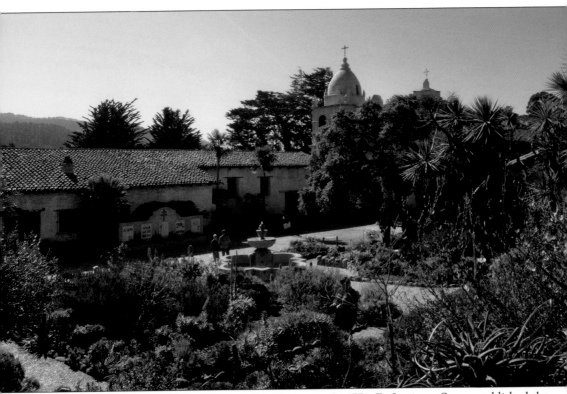

Mission San Carlos Borromeo del Río Carmelo. In 1771, Fr. Junípero Serra established the Carmel Mission, located on 3080 Rio Road, near the mouth of the Carmel River. He founded 9 of the 21 missions in California, ran them from there, and was buried at the mission. Master builder Manuel Esteban Ruiz constructed the Basilica in 1793–1797. The mission fell into disrepair in the mid-1800s, was repaired in the 1880s, and was rededicated in 1884, the year of the 100th anniversary of Serra's death. The second mission restoration began in the early 1930s under Harry Downie, a San Francisco cabinetmaker with Spanish antiques expertise, who spent nearly five decades refurbishing it. From 2012 to 2016, the third mission restoration included a seismic retrofit of the Mission Basilica and repair of the quadrangle courtyard.

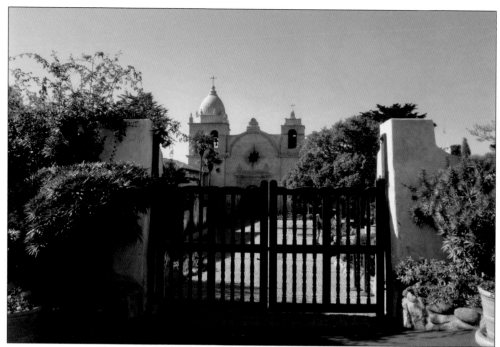

CARMEL MISSION ENTRANCE. The Carmel Mission, a parish church, was designated a Minor Basilica in 1961. It is a California State Landmark, a National Historic Landmark, and is listed in the National Register of Historic Places. Pope John Paul II visited the mission in September 1987. There is an admission fee to visit the grounds, museums, and Basilica.

FR. JUNÍPERO SERRA SHRINE, CARMEL WOODS. Artist Joseph ("Jo") Jacinto Mora (1876–1947), who made the Carmel Mission's Serra Memorial Cenotaph, designed this carved wood statue of Father Serra in northwest Carmel for real estate developer Samuel F.B. Morse's (1885–1969) new subdivision. Unveiled on Serra Day, July 22, 1922, it is located at the intersection of Alta and Serra Avenues, Dolores Street, and Camino del Monte.

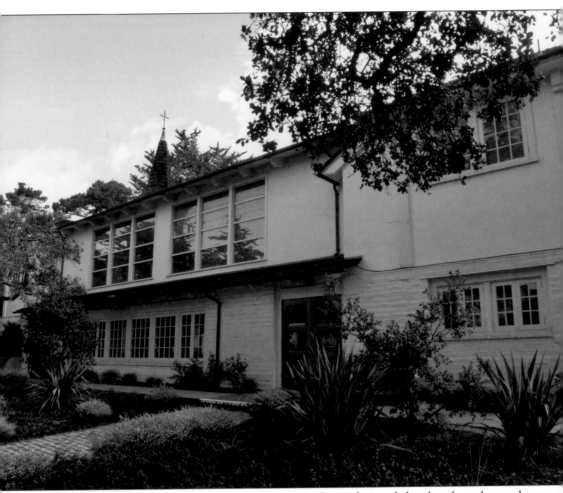

CARMEL PRESBYTERIAN CHURCH. Architect James Pruitt designed the church at the southeast corner of Ocean Avenue and Junipero Street at Mountain View Avenue in 1954. It was built using the Post-Adobe construction method. In 1956, Pres. Dwight D. and First Lady Mamie Eisenhower visited the church.

Four

THEATERS, GALLERIES, AND ART

SUNSET SCHOOL PRIMARY CLASSROOMS NOS. 16 AND 17 (LEFT) AND 18 (RIGHT). In 1929, M.J. Murphy designed and constructed these classrooms resembling residential cottages on the southern end of the Sunset School property—on the northwest corner of Mission Street and Tenth Avenue and 2NW of Mission Street and Tenth Avenue, respectively. Most recently, they were being used as adult classrooms and office space for cultural organizations.

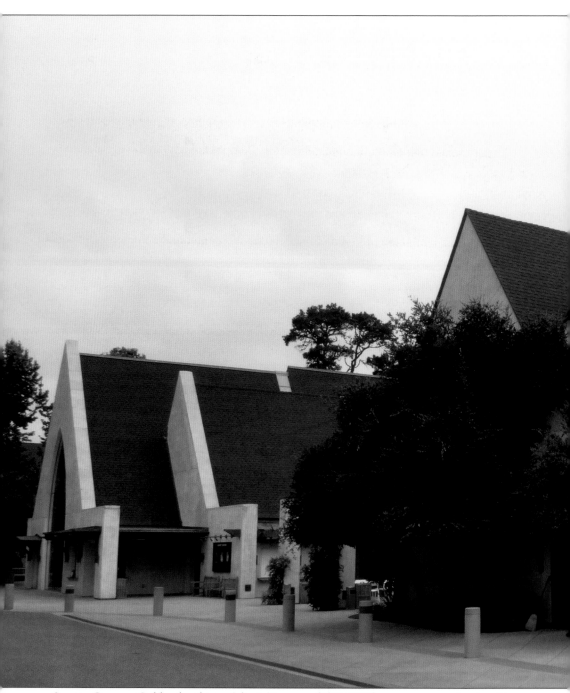

Sunset Center. Oakland architect John J. Donovan (1876–1949), an expert on school architecture, designed the Tudor Revival–style Sunset School in 1925 on San Carlos Street and Ninth Avenue. In 1931, architect Columbus J. ("C.J.") Ryland (1892–1980) and M.J. Murphy built the Sunset School's massive Gothic Revival–style auditorium annex. The property, spanning two city blocks, was sold to the city as a community center in 1965. The 718-seat auditorium is the longtime

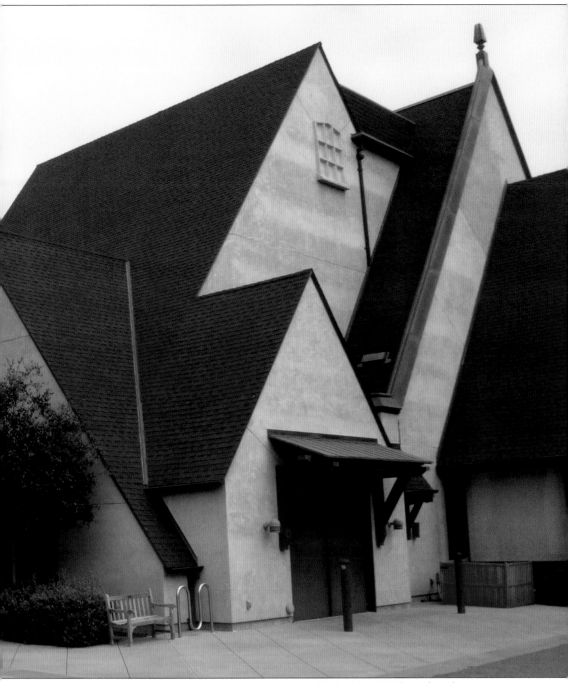

home of the world-renowned Carmel Bach Festival, established in 1935 by cultural impresarios Dene Denny (1885–1959) and Hazel Watrous (1884–1954) along with the Carmel Music Society, (which began in 1927), Chamber Music Monterey Bay, and Monterey Symphony. It was listed in the National Register of Historic Places in 1998 thanks to the effort of historic preservationist Enid Sales, and it underwent a $21-million renovation in the early 2000s.

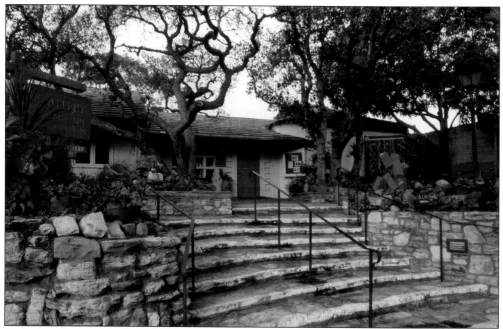

CARMEL ART ASSOCIATION (ABOVE) AND SCULPTURE GARDEN (BELOW). The organization of artists known as the Carmel Art Association formed in 1927 but did not have their own gallery until 1933, when local businessman and banker Barnet J. Segal (1898–1985) bought the former studio of actor, poet, and artist Ira Remsen (1876–1928) on Dolores Street 3SW of Fifth Avenue. This one-story building was expanded in 1938 by artist and architect Clay Otto (1891–1980). A tall Carmel stone retaining wall was added outside, along with the sculpture garden in front of the building, which was designed by artist William P. Silva (1859–1948).

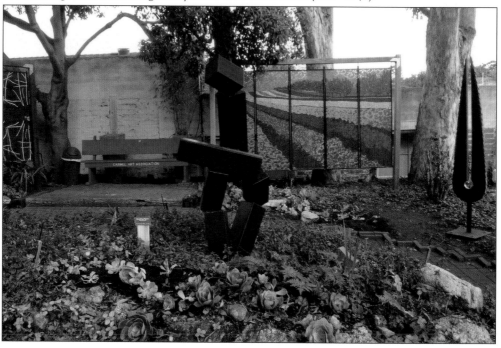

PHOTOGRAPHY WEST GALLERY.
Located in the Draper-Leidig
building (see page 82) on Dolores
Street 2SE of Ocean Avenue,
this gallery features works by
Ansel Adams (1902–1984),
Brett Weston (1911–1993),
and many other prominent
West Coast photographers,
with an exclusive emphasis on
printed film photographs. It
has been open since 1980.

**CENTER FOR PHOTOGRAPHIC
ART.** This gallery, originally the
Sunset School library located
on the northeast corner of San
Carlos Street and Ninth Avenue,
was begun by three photographic
legends: Ansel Adams, Cole
Weston (1919–2003), and
Wynn Bullock (1902–1975). It
is the second-oldest nonprofit
photography gallery in the United
States, and its history is linked
with the Friends of Photography
gallery, which began in 1967.

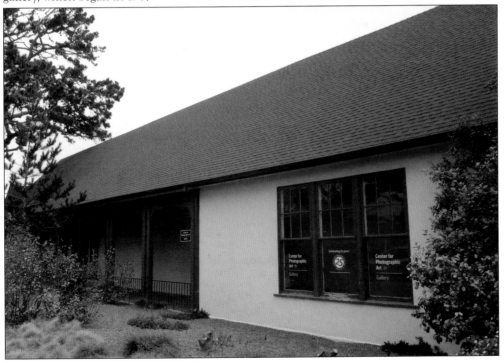

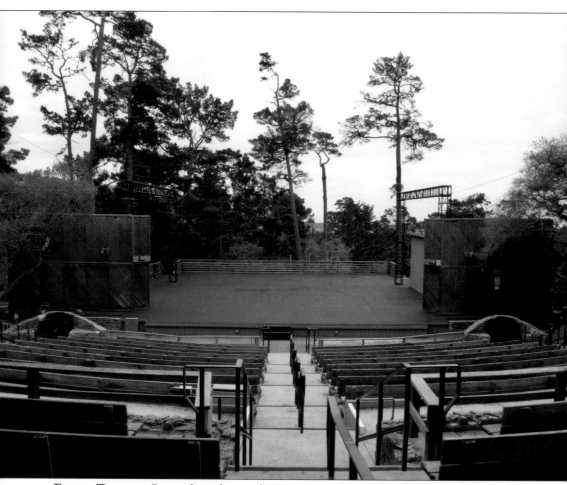

FOREST THEATER. Situated on the northeast corner of Santa Rita Street and Mountain View Avenue and founded by Bohemian actor and businessman Herbert Heron (1883–1968) in 1910, this city-owned venue is one of the three oldest open-air theaters in the West. The basic appearance of the raised stage and bench-like seating remain virtually the same; however, there have been upgrades and renovations, along with threats of closure, over the decades. It seats 540 people. The theater shut down during the Great Depression and was reconstructed with WPA funds in the late 1930s. It also closed during World War II. In the 1970s, the Forest Theater was in danger of being torn down and turned into a city parking lot. It underwent numerous renovations in the 1980s, 1990s, and from 2013 to 2016. In 2010, the city celebrated the 100th anniversary of the theater's founding.

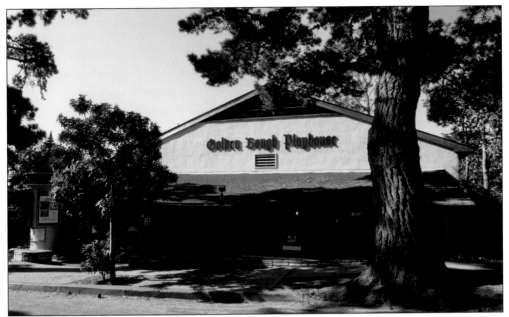

GOLDEN BOUGH PLAYHOUSE (ABOVE) AND CIRCLE THEATRE (BELOW). The two-story stage and film theater was designed in 1951 by architect James Pruitt of Comstock Associates on Monte Verde Street 4NW of Ninth Avenue, on the site of the second Golden Bough Theater, which burned in 1949. The kiosk was added in 1967. It was a United Artists movie theater until 1993, when Pacific Repertory Theatre bought it and renamed it the Golden Bough Playhouse. It seats 300. The smaller theater behind it on Casanova Street 3NE of Ninth Avenue is the Circle Theatre, which seats 120.

DE YOE BUILDING. M.J. Murphy designed and built this Tudor Revival–style building for realtor Ray C. De Yoe (1879?–1933) on Dolores Street 4NE of Seventh Avenue in 1924. During the 1920s and 1930s, it housed the *Carmel Pine Cone* newspaper offices and the Denny-Watrous art gallery (1927) and stage (1931), which presented avant-garde art, photography, music, and architecture exhibits and lectures. It is now home to several art galleries.

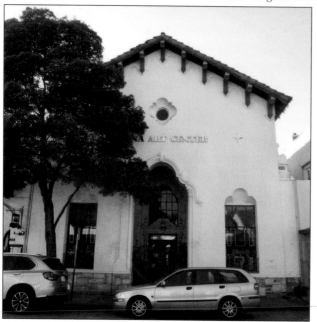

MONTEREY COUNTY TRUST AND SAVINGS BANK. The large two-story Spanish Mission Revival–style building on Dolores Street 2NW of Seventh Avenue was the work of San Francisco architectural firm H.H. Winner, which specialized in banks and designed others in the area. Built in 1929 with Hugh Comstock as contractor, it became the Carmel Museum of Art in 1967. It was run by members of the Chew family in the 1970s until it closed in 2017.

ROBERT JONES–DESIGNED BUILDING. Modernist architect Robert Jones designed this post–World War II commercial building on Sixth Avenue 3SE of Monte Verde Street in the Second Bay Region architectural style. The ground floor is an art gallery. Jones won an award for his design of the Monterey Peninsula Airport in 1950.

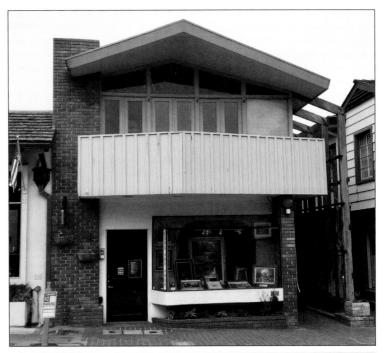

CARMEL BALLET ACADEMY. This dance studio was built for Mr. and Mrs. Dudley Nix in 1954 and designed by architects Thomas Elston and William Cranston in a contemporary style using Post-Adobe construction. It is located above street level on Mission Street 2NW of Eighth Avenue. Known for many generations as a ballet studio, it is now the Carmel Academy of Performing Arts.

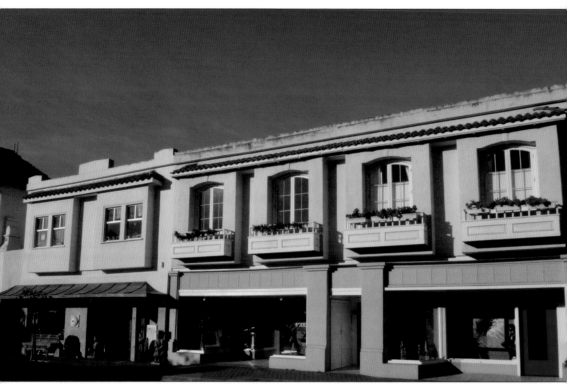

T.A. Oakes Building (left) and Oakes Building (right). These two buildings share a common wall. The one on the left, located on Dolores Street 3NW of Seventh Avenue, was built first, in 1922, and served as the post office from 1922 to 1934 and as city hall from 1927 to 1946. It also housed the police station and council chambers, all on the upper floor. The structure on the right was built the following year, in 1923, on Dolores Street 4NW of Seventh Avenue. The architect for both was Thomas Morgan and the builder was T.A. Oakes of Santa Cruz. The architectural style is described as Western False Front Commercial–Spanish Revival. Both structures have undergone numerous changes. The building on the left was altered on the first floor in 1959 by architects Elston and Cranston and is the longtime home of Conway of Asia, an Asian antique gallery; the one on the right is original on the ground floor and home to the New Masters Gallery. Both are residential on the second floor.

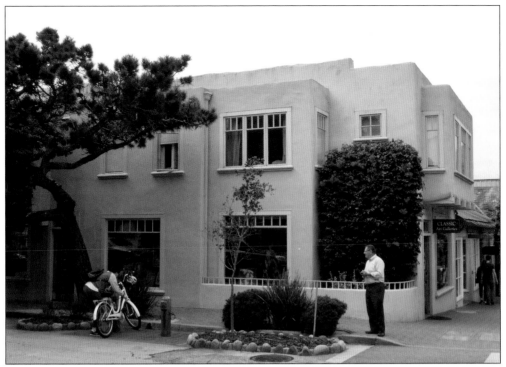

MARY DUMMAGE SHOP (1). Pioneering landowner and businesswoman Mary Norton Dummage (1870–1952), Philip Wilson's sister-in-law, purchased several parcels along Ocean Avenue and Dolores Street in 1903. In 1924, Percy Parkes designed and built the Pueblo Revival–style building at the southwest corner lot. The upstairs level is residential. For 75 years, the lower floor was the Corner Cupboard retail store; it recently became an art gallery.

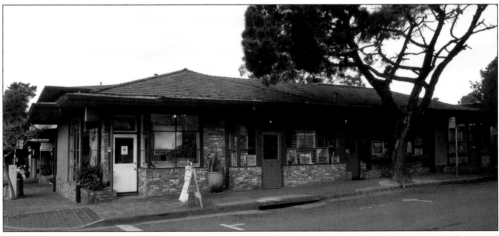

FRANCIS PALMS–DESIGNED OFFICE BUILDING. Architect Francis Palms (1910–1982) designed this one- and two-story commercial complex with a brick patio court on the northwest corner of Dolores Street and Sixth Avenue in 1955. It has several ground-floor art galleries and the Weston Gallery, a photography gallery open since 1975. Palms was the cofounder and first president of the Monterey Bay Chapter of the American Institute of Architects, established in 1953, which had architect Frank Lloyd Wright (1867–1959) as its opening guest speaker.

CARL CHERRY CENTER FOR THE ARTS (ABOVE) AND STUDIO (BELOW). A Queen Anne–style cottage was built for Augusta Robinson in 1894 on the northwest corner of Guadalupe Street and Fourth Avenue by carpenter Delos Goldsmith. In 1948, it was expanded into a fine arts center, with a gallery and 50-seat theater, and named in honor of Carmel resident Carl Cherry, who invented a revolutionary rivet used in World War II airplanes and ships. His widow, bohemian painter and poet Lena Cherry (1887–1964), a.k.a. Jeanne D'Orge, established the experimental performing and fine arts foundation after his death in 1947. Modernist English-born architect and structural engineer Paffard Keatinge-Clay (b. 1926), who trained with world-renowned architects Le Corbusier, Frank Lloyd Wright, and Mies van der Rohe, designed the art studio, which is now used as an office, on the property in 1952.

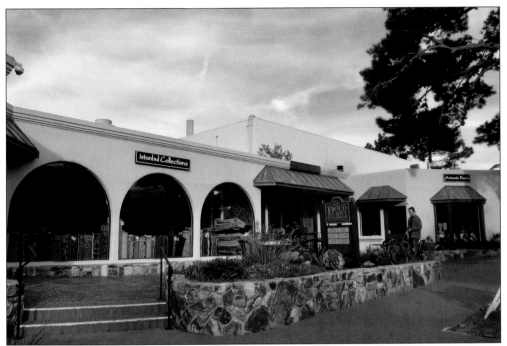

CARMEL CRAFT STUDIOS (ABOVE) AND CALIFORNIA DEL NORTE VIA EL CAMINO REAL (BELOW). In 1955, local landscape painter Fred Klepich (1915–1980) and businessman August Nieto, owner of Su Vecino restaurant, partnered to establish shops with studios for local artists and craftsmen to create and sell their work, in the tradition of Carmel's earliest creative bohemians. Architects Thomas Elston and William Cranston remodeled the building's interior, owned by James Doud, on San Carlos Street 3SW of Ocean Avenue. That same year, Fred's wife, artist Mary Miller Klepich (1919–1957), painted the exterior facade mural, *California Del Norte via El Camino Real*, which depicts historic figures from pre-statehood California eras. In 2002, it was restored by local artist and master woodcarver Earl Bozlee (1932–2013). The Craft Studios connect to the Doud Arcade building (see page 92).

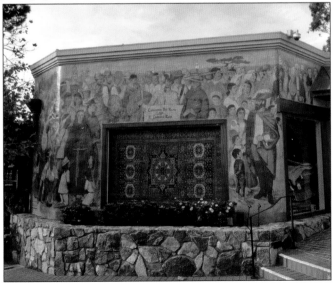

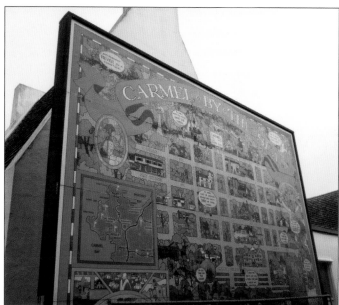

MAP OF CARMEL. Popular Carmel cartoonist Bill Bates (1930–2009), known for his comic observations of Carmel life in the *Carmel Pine Cone* and on the interior walls of the Carmel Post Office, created this humorous map of the town along with artist Carol Minou (1946–2012) in the 1980s. Painted with acrylic on wood, it is located on the north wall outside Nielsen Bros. Market (see page 89).

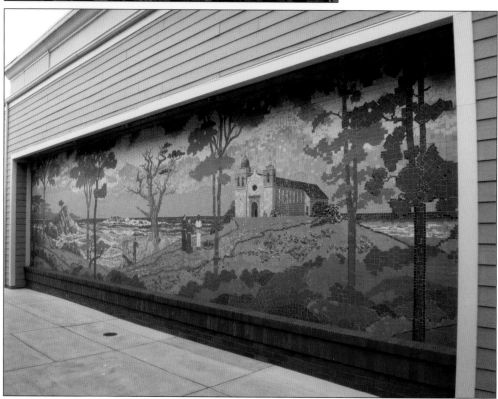

JOHN GARTH MURAL. In 1968, San Francisco artist and teacher John Garth (1889–1971) created this outdoor mosaic mural depicting the Carmel Mission and Pacific coastline for the Carmel Crossroads Safeway store near Highway One and Rio Road. It was the last of several mosaics he did for the grocery chain's Northern California store exteriors. Saved from demolition in 2006, it was moved nearby, across from Ace Hardware.

Five

HOTELS AND RESTAURANTS

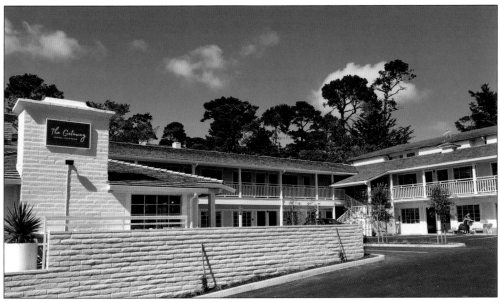

THE VILLAGE INN. Architect James Pruitt of Comstock Associates designed this two-story motel in 1954, combining Monterey Colonial and Tudor elements with Post-Adobe construction on the northeast corner of Junipero Street and Ocean Avenue, the site of the original 1889 Hotel Carmelo. It underwent renovation and got a new name, The Getaway, in 2018.

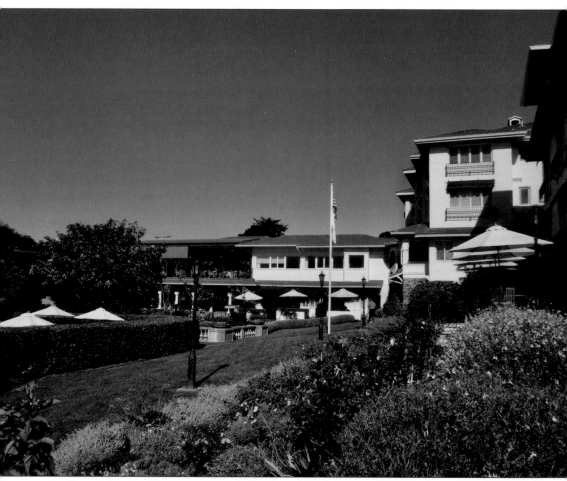

LA PLAYA HOTEL. The stone mansion built in 1905 by artist Christian Jorgensen (1860–1935) and his wife, San Francisco chocolate heir Angela Ghirardelli (1859–1936), is on the southwest corner of Camino Real Street and Eighth Avenue. It was eventually sold to Agnes Signor, who turned it into a 20-room hotel in the 1920s with her two nephews, Harrison and Fred Godwin, who became owners. M.J. Murphy rebuilt the hotel in 1925. In 1940, designer Jon Konigshofer did a major Spanish Revival–style remodel and expansion to 80 rooms and created the Terrace Dining Room overlooking Carmel Bay. In 1952, the hotel obtained a liquor license, and Konigshofer designed the Lanai Room cocktail lounge. The Godwin family had a 77-acre ranch, Rancho La Playa, 10 miles into Carmel Valley, where guests went to escape the coastal fog. In 1958, a Pebble Beach tennis pro turned the land into the exclusive John Gardiner's Tennis Ranch (which closed in 2009), designed by Konigshofer and landscape architect Thomas Church. The hotel underwent ownership changes in the 1960s, 1980s, and 2012, along with renovations.

SWIMMING POOL AT LA PLAYA. During the 1980s, top members of Apple Computer's development team came down from Silicon Valley for retreats; the Macintosh computer prototype was unveiled by Steve Jobs at the hotel in 1983. At this gathering, the rowdy Apple employees skinny-dipped in the pool after hours and were banned from the hotel for 30 years until 2012, when new management lifted the ban.

DOLPHIN INN. Architect Francis Palms designed the two-story Monterey Colonial–style hotel on the northeast corner of San Carlos Street and Fourth Avenue in 1963, and it was built by Geyer Construction of Monterey. In 2015, new owners remodeled and renamed it Hotel Carmel, now a sister property to La Playa.

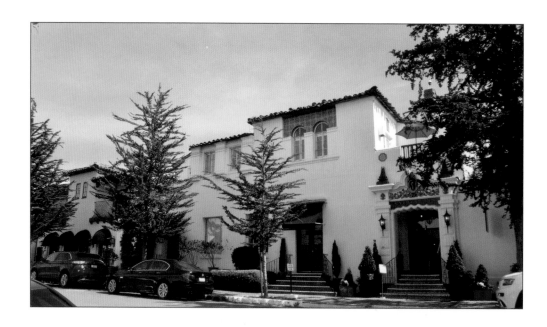

HOTEL LA RIBERA (CYPRESS INN), LINCOLN STREET (ABOVE) AND SEVENTH AVENUE (BELOW).
Oakland architects Roger Blaine and David Olson designed the Spanish Eclectic–style hotel for
Dr. Rudolph A. Kocher in 1929 on the northeast corner of Lincoln Street and Seventh Avenue.
During the 1930s, musical performances were regularly held there. Hotel guests of La Ribera,
along with Pine Inn and La Playa, were frequently written about in the society columns of local
newspapers. The hotel was expanded in the late 1940s by San Francisco architect Gardner Dailey
(1885–1967), and later renamed Cypress West. Actress and singer Doris Day (b. 1922) first fell in
love with the Monterey Peninsula when she filmed the 1956 movie *Julie* on location. She eventually
moved to Carmel and became co-owner of the hotel, now the Cypress Inn, in the 1980s.

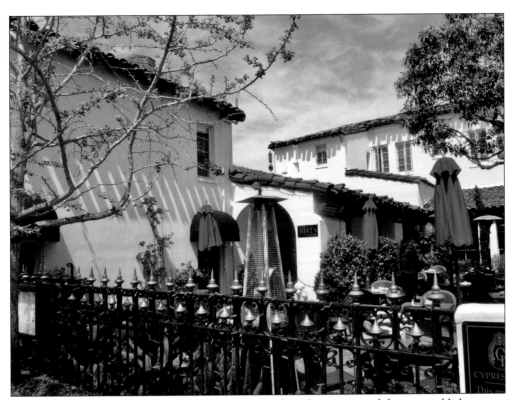

TERRY'S RESTAURANT AND LOUNGE. The indoor and outdoor courtyard dining establishment at the Cypress Inn is named after Doris Day's late son, music producer Terry Melcher (1942–2004). The bar features retro-style cocktails from the 1920s, 1930s, and 1940s. Some nights, there is live piano music and singing. Vintage Hollywood memorabilia from Doris Day's career is on display inside. Dogs are welcome.

CHARLIE CHAPLIN MURAL. Hollywood actor Charlie Chaplin (1889–1977) was a regular visitor to Carmel and Pebble Beach in the 1930s, part of the high-society and artistic social scene. This courtyard wall mural along Seventh Avenue was done in 2010 by the French-born, Los Angeles–based street artist known as "Mr. Brainwash," a.k.a. Thierry Guetta (b. 1966).

GREEN LANTERN INN. The quaint, historic inn on the southeast corner of Casanova Street and Seventh Avenue is about one block from the downtown district. The 17-room bed-and-breakfast inn is made up of six unique cottages and has been in operation since 1927.

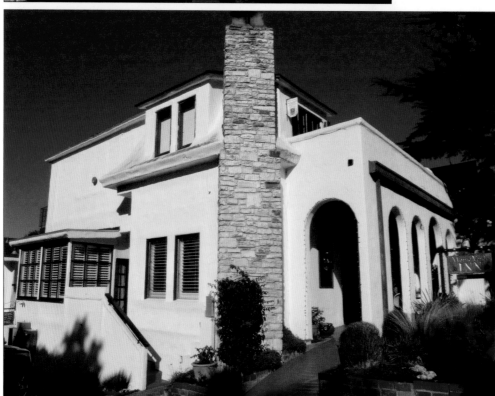

MONTE VERDE INN. The small Mediterranean-style hotel, currently located on Monte Verde Street 3SW of Ocean Avenue, was an early-1920s apartment complex purchased in 1924 by Ethyl P. Young, mother-in-law of architect Robert Stanton. It was moved from its corner location in the 1930s for the construction of the Normandy Inn, and it has been the Monte Verde Inn since the 1950s.

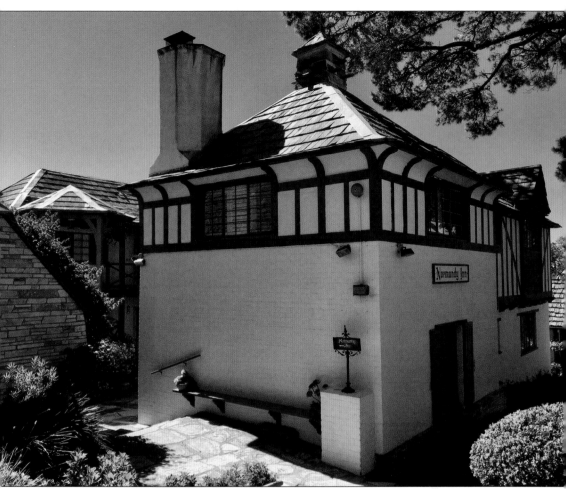

NORMANDY INN. The two-story French Revival–style hotel, which spans the south side of Ocean Avenue between Monte Verde and Casanova Streets, was built in 1936 for Ethyl Young of Pebble Beach, a significant landowner in downtown Carmel. In 1937, she added the Normandy Apartments, visible in the background, which also became part of the hotel. Her son-in-law, architect Robert Stanton, did many expansions from the 1930s to the 1960s; he and his wife, Virginia, owned the hotel through the 1980s. Stanton's highly-regarded works are two large Art Deco–Moderne WPA projects, both listed in the National Register: the King City Joint Union High School Auditorium and the Monterey County Courthouse in Salinas. Artist Jo Mora did sculptural work for both.

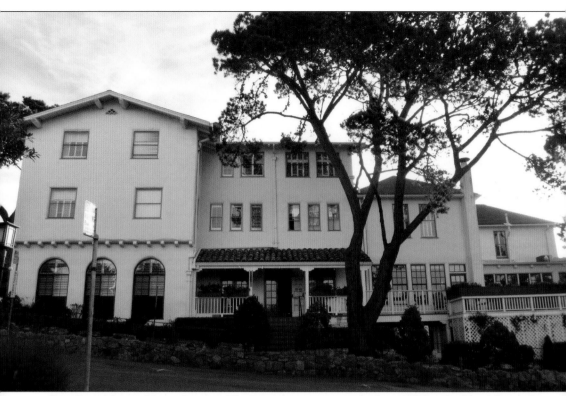

PINE INN, MONTE VERDE STREET. The Pine Inn's origins go back to 1889 as the Hotel Carmelo, built at the entrance to town. It was moved to its present location at the northeast corner of Ocean Avenue and Monte Verde Street in 1903 and expanded by San Francisco architect Thomas Morgan with builder M.J. Murphy. In 1928, Oakland architects Blaine and Olson enlarged the hotel to three stories and gave it a Spanish Eclectic character still noticeable today; Murphy was the contractor. The owner at that time was John B. Jordan, actor, businessman, and Carmel's mayor in the 1920s. In the early 1940s, Harrison Godwin, former La Playa co-owner, bought the hotel and hired designer Jon Konigshofer to expand it with retail and office space to cover an entire city block up to Lincoln Street between Ocean and Sixth Avenues. The contractor was Harold C. Geyer of Monterey. Earlier, Godwin and Konigshofer took a Southern California trip to see Beverly Hills boutiques for inspiration, and with his movie-star looks, Konigshofer took a Hollywood screen test while he was there.

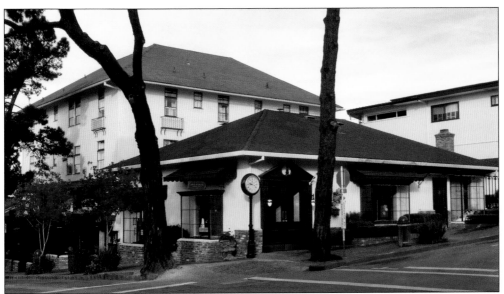

PINE INN GARDEN SHOPS (ABOVE) AND COURTYARD (BELOW). Fourtané Jewelers (above), located at the northwest corner of Ocean Avenue and Lincoln Street, once a bank building, has been in business since 1950. Along with designing 12 new shops in 1941, Jon Konigshofer redesigned the Pine Inn's large restaurant dining room, outdoor terrace dining area, and what is now Il Fornaio restaurant's coffeehouse. He moved his office to the Pine Inn. Bay Area landscape architect Thomas Church's inner patio garden with brick courtyard and pathways created the garden setting. Konigshofer and Church collaborated on numerous Monterey Peninsula architectural projects throughout the 1940s and 1950s, such as Carmel's Mayfair Apartments (1941) and Hollywood producer Robert Buckner's (1906–1989) Pebble Beach house (1947) featured in the 1949 San Francisco Modern Art Museum exhibit *Domestic Architecture of the San Francisco Bay Region*.

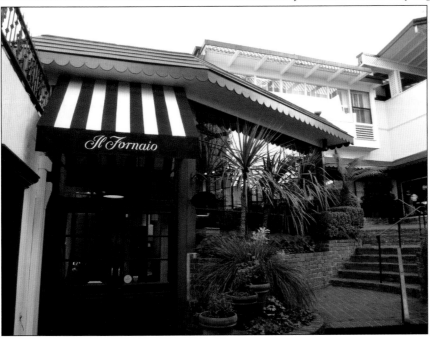

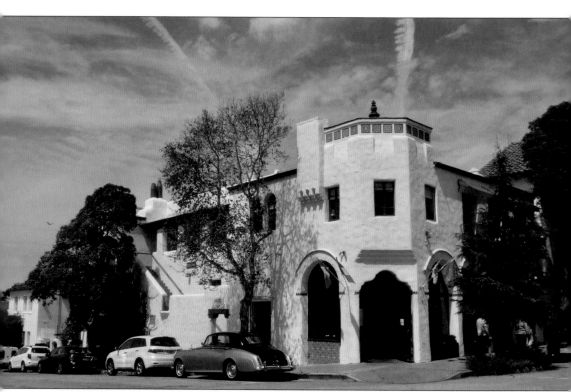

LA GIRALDA (KOCHER BUILDING). Constructed in 1927 on the northwest corner of Dolores Street and Seventh Avenue, this building has been called the best example of the Spanish Colonial Revival architectural style that was predominant from 1925 to 1935 in downtown Carmel's commercial district. Designed by Oakland architectural firm Blaine and Olson, which contributed five major downtown commercial buildings in Carmel during the late 1920s, it was the first of two done for Dr. Rudolph Kocher; the second was neighboring Hotel La Ribera (1929) (see pages 50 and 51). These two buildings, along with El Paseo (1928), also by Blaine and Olson, (see page 58–61) complemented each other and created the look of an Andalusian Spanish hill town up Seventh Avenue. All three had towers. In view of large earthquakes in Japan (1923) and Santa Barbara (1925), La Giralda had a steel frame. Architects Roger Blaine and David Olson designed several post-quake buildings in the Spanish Colonial Revival style in downtown Santa Barbara. La Bicyclette restaurant is now on the ground floor; it began in 1974 as La Bohème, established by Belgian-born Walter Georis (b. 1945), a Carmel artist and restauranteur.

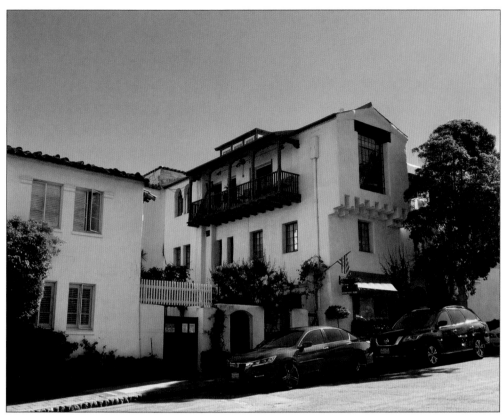

LA GIRALDA, SEVENTH AVENUE REAR VIEW (ABOVE) AND RESIDENTIAL ENTRYWAY (RIGHT). Dr. Rudolph Kocher's patron was Grace Deere Velie (1872–1929), a farm equipment manufacturing heiress who endowed the 1930 Metabolic Clinic in northeast Carmel along Highway One, designed by San Francisco architect (and later part-time Carmel resident) Gardner Dailey. Dr. Kocher, also a researcher, was director of the facility, which became Peninsula Community Hospital in 1934. During World War II, Dr. Kocher served as a colonel in the Army Medical Corps. La Giralda had a pharmacy on the ground level and doctor's offices on the second floor (now residential) with a hand-carved caduceus over the entrance. Architects Blaine and Olson had visited Spain and appreciated old Spanish decorative architectural details such as colorful handmade tile, hand-carved woodwork, and hand-forged ironwork. Local blacksmith Francis Whitaker, who trained under master blacksmith Samuel Yellin (1884–1940), did the ironwork.

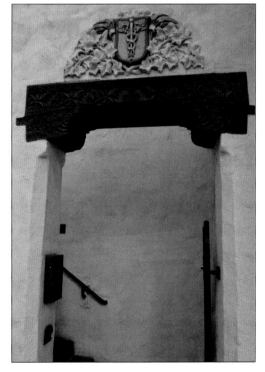

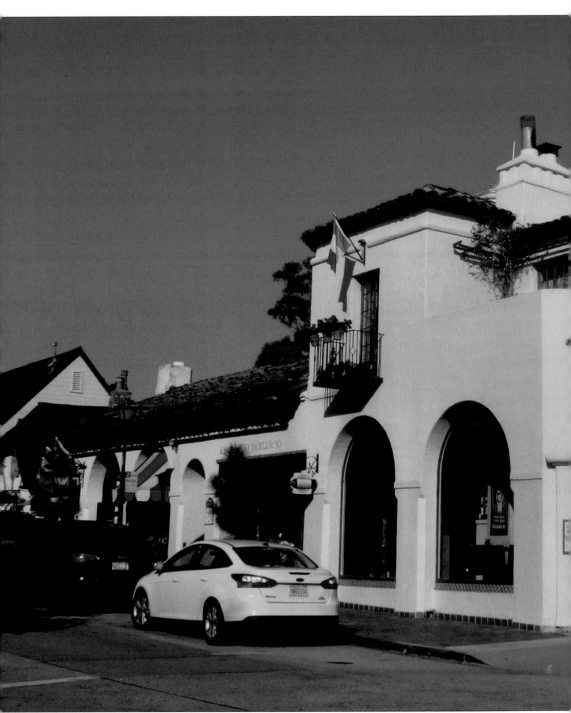

EL PASEO BUILDING. The large two-story Spanish Eclectic–style building on the northeast corner of Dolores Street and Seventh Avenue was constructed in 1928 for businessman Lewis Charles ("L.C.") Merrell. He commissioned architects Blaine and Olson to design the structure, with construction by C.H. Lawrence—both Oakland firms. Concurrently, Merrell hired the architects to design his massive two-story Spanish Colonial Revival–style mansion in neighboring Pebble

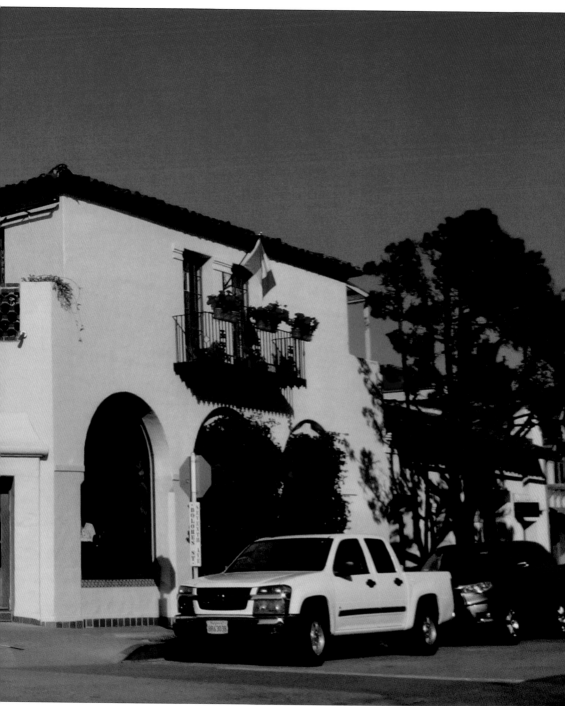

Beach, featured in the July 1930 issue of the trade magazine *California Arts & Architecture*. Merrell added a nine-hole golf course to the property. El Paseo underwent three ownership changes in its early years. In 1990, local restauranteur and one-time mayoral candidate (in 2012) chef Rich Pèpe opened the Italian restaurant Little Napoli on the ground floor. It was featured in 2014 on the Food Network show *Diners, Drive-ins, and Dives*, hosted by chef Guy Fieri.

EL PASEO, DOLORES STREET PASSAGEWAY (ABOVE) AND *THE GREETING* (BELOW). El Paseo means "the passageway" in Spanish, and two passageways to the central courtyard are paved with rough, red tiles: one coming from Dolores Street and the other from Seventh Avenue. Art and civic leader L.C. Merrell wanted the building to be artistic as well as useful; he was a founding member and charter director of the Monterey History and Art Association in 1931. He personally selected artist and sculptor Jo Mora to design the outdoor polychrome terra-cotta sculpture group in the courtyard, *The Greeting* (1928), which represents a scene from 1840s California (before statehood). In 1939, the city considered the purchase of El Paseo as a new city hall and police station, with interior alteration design changes by architect C.J. Ryland, but that plan was not enacted.

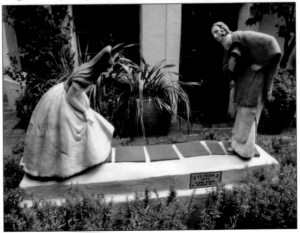

EL PASEO TILE FOUNTAIN (RIGHT) AND STAIRCASE WITH TILE AND IRONWORK (BELOW). The mixed-use building has kept its 1928 original look. This tile fountain at the Dolores Street entrance is incorporated into the staircase wall leading to the second floor, which remains residential. The staircase has imported handmade tiles from Spain and locally-fabricated wrought iron, most likely created by Francis Whitaker. Former Carmel mayor and journalist Perry Newberry wrote about El Paseo's construction in the October 1928 issue of *The Architect and Engineer*. He described the distinctive features and artistic details such as the custom handmade tiles and hand-forged ironwork used throughout the building. Newberry concluded, "There is a distinction about every detail of the building"; it is an "architectural gem."

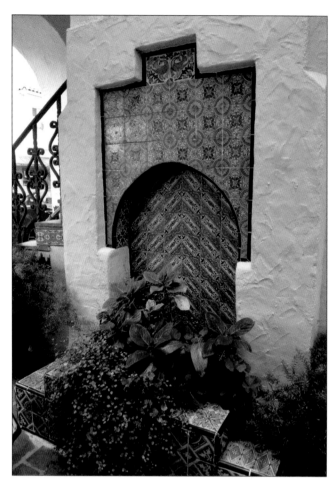

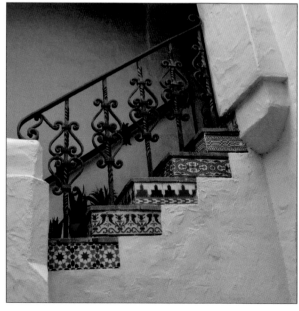

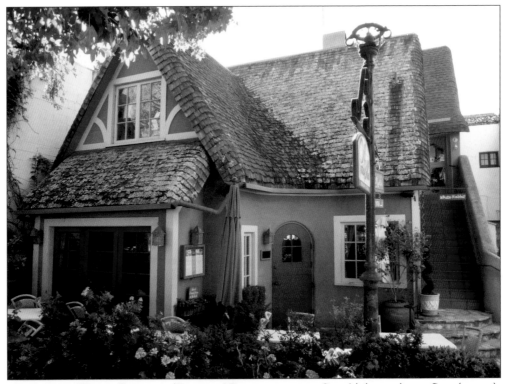

HARRY LEON WILSON BUILDING (BLOOMIN' BASEMENT, LATER SADE'S) (ABOVE) AND SIDE (BELOW). In 1925, nationally popular Carmel Highlands author and screenwriter Harry Leon Wilson (1867–1939) commissioned this Tudor Revival–style building, constructed by Lee Gottfried, for his third wife, Helen MacGowan Cooke (1895–1945), on Ocean Avenue 3SW of Lincoln Street. Cooke's flower shop, Bloomin' Basement, was on the ground floor. During the 1930s, the building also had a dress shop, Carmelita, run by Harry and Helen's daughter Charis (1914–2009), who met photographer Edward Weston (1886–1958), whose studio was nearby at the Seven Arts Building, and married him in the late 1930s. The ground floor became Sade's, a popular bohemian bar and restaurant frequented by local writers, artists, and musicians and co-owned by Carmel resident actress Kim Novak (b. 1933) during the 1980s. It remains a restaurant with outdoor seating.

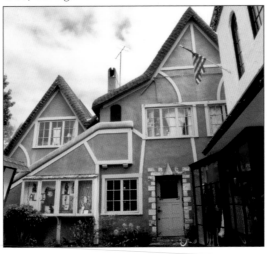

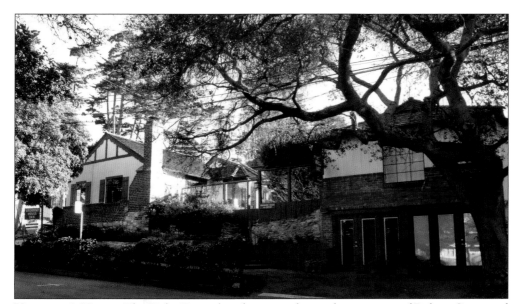

VAGABOND'S HOUSE. The Tudor Revival–style inn on the southeast corner of Dolores Street and Fourth Avenue has 1920s roots and was expanded in the early 1940s. In 1947, it was renamed Vagabond's House Apartments for popular part-time 1930s–1940s Carmel resident Donald Benson Blanding (1894–1957). The world traveler, poet, and illustrator was best known for his book *Vagabond's House* (1928).

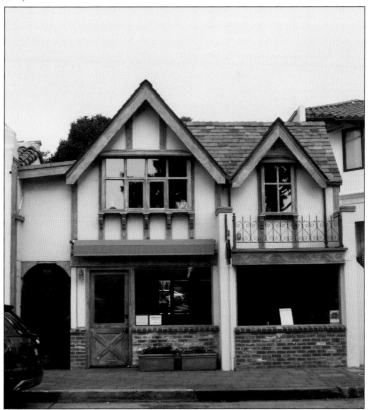

ENCHANTED OAKS. The Tudor Revival–style commercial building, constructed in 1927 on Seventh Avenue 2NE of Dolores Street, was remodeled in 1931 and 1941 by Ernest Bixler. Prolific Hollywood television and music composer Alan Silvestri (b. 1950) now has a wine-tasting room for his Carmel Valley vineyard on the ground floor.

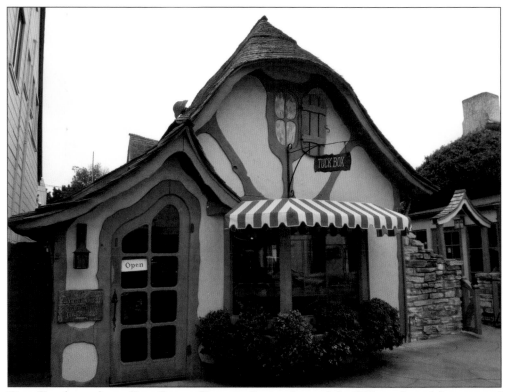

Tuck Box (above) and East Side of Dolores Street (below). In 1926, residential designer and builder Hugh Comstock launched a Fairy Tale–Storybook style architectural trend downtown with his first commercial structure, built for Bonnie Lee, located on Dolores Street 2NE of Seventh Avenue. Always a restaurant (earlier known as Sally's), in the early 1940s, it became an English tearoom, Tuck Box, and has remained as such. The landmark building contributes to the distinctive, European-inspired appearance of downtown and is Carmel's most internationally recognized and photographed building. This stretch of Dolores Street between Seventh and Ocean Avenues is the foremost historic block and was the heart of the downtown district from the 1920s through the 1950s.

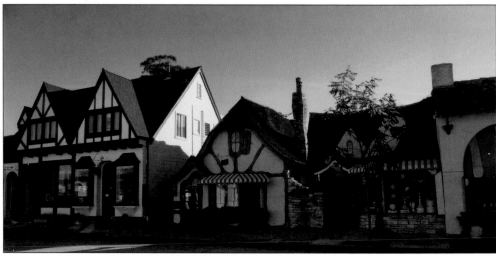

PATISSERIE BOISSIÈRE.
Established on Mission Street 3NE of Seventh Avenue in 1961 by husband and wife Elaine and Pierre Boissière, who died in 1987, their restaurant continued under new ownership. The French-style château building is one of the oldest restaurants still operating downtown.

CASANOVA. In 1977, restauranteur and vintner Walter Georis remodeled a c. 1920 house on Fifth Avenue 2SE of San Carlos Street into the restaurant reminiscent of his grandmother's house in Belgium. Previously, it was the home of Charlie Chaplin's local cook and her husband. Georis added an enormous wine cellar in the 1980s.

SCHWEINGER BUILDING (CARMEL BAKERY). The Western false front–style, two-story building with Victorian details on Ocean Avenue 4SW of Dolores Street has been continuously in operation, harkening back to around 1899–1910, along with the Adam Fox building (page 79). The upper floor is residential. It has remained a bakery since it opened.

HOG'S BREATH INN. Clint Eastwood, along with business partners, opened this restaurant and bar on San Carlos Street 3SW of Fifth Avenue in 1972 and sold it in 1999. The wood-carved boar's head was done by Earl Bozlee, and this remains a popular photography spot.

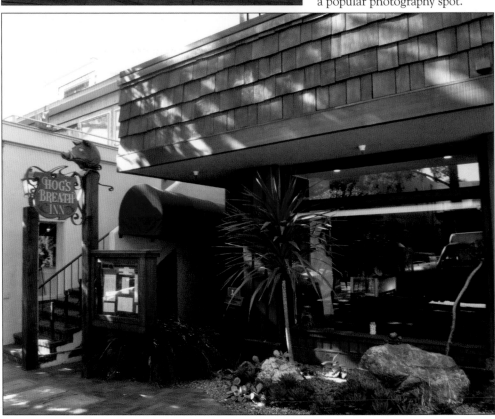

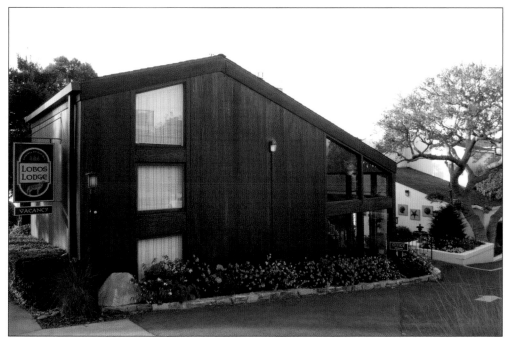

LOBOS LODGE. The motel on the northwest corner of Ocean Avenue and Monte Verde Street began as 1920s guest cabins to house extra Pine Inn visitors. In 1973, the cottages were torn down and then completely rebuilt in 1974 in the Third Bay Region style, designed by architect Will Shaw, with a courtyard, fountain, and shops.

NORTHERN CALIFORNIA SAVINGS AND LOAN. In 1972, architect Walter Burde designed this Third Bay Region–style building on the southeast corner of Dolores Street and Seventh Avenue. It was transformed from a bank into retail space, then threatened with demolition and a decade of litigation before becoming an event center briefly (2013–2016) and a restaurant in 2017.

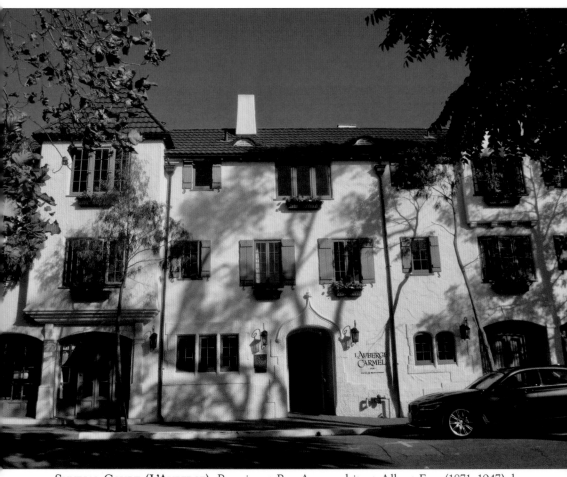

SUNDIAL COURT (L'AUBERGE). Prominent Bay Area architect Albert Farr (1871–1947), known for his grand mansions in San Francisco's Pacific Heights and East Bay, designed the building. He was the uncle of former State Sen. Fred Farr and great-uncle of former US Congressman Sam Farr. The hotel began as an apartment complex with an interior court in 1930 on Monte Verde Street 2NE of Seventh Avenue on land that belonged to Allen Knight's family. M.J. Murphy did the construction. The three-story Medieval Revival–style building had shops on the ground floor. It became a hotel, renamed the Sundial Lodge in the 1960s, and later L'Auberge in 2002. A restaurant was added in 1978.

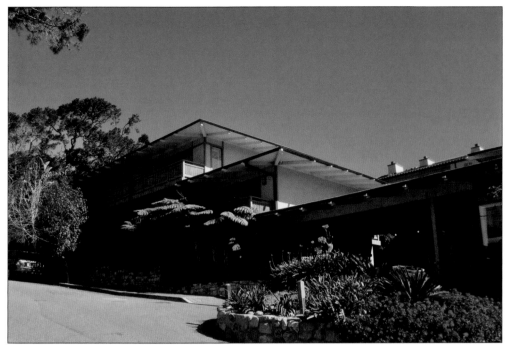

TRADEWINDS. Realtor Richard ("Dick") Montgomery Catlin (1911–1998), a World War II Air Force veteran, designed the Asian-inspired hotel on the southeast corner of Mission Street and Third Avenue in 1959 based on his postwar years in Japan. The hotel, with its tropical, Zen meditation garden, was remodeled and featured in *Architectural Digest* in 2004.

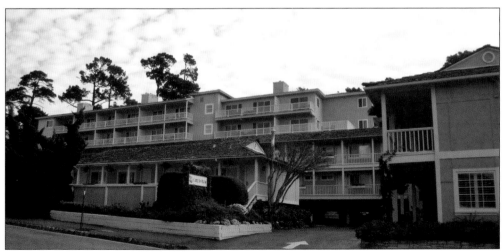

JADE TREE MOTEL. This large, Monterey Colonial–style hotel, which had Japanese-inspired gardens and a swimming pool, was built in 1959 on Junipero Street 2NE of Sixth Avenue. It was controversial at the time, as some residents perceived it as too big and suggested that the town was becoming too tourist-oriented.

VILLAGE CORNER. This restaurant with an outdoor patio on the northeast corner of Dolores Street and Sixth Avenue has been open since 1948. It was constructed in the Post-Adobe method, popular in the era after World War II. A group of residents saved it from demolition in 1976. In later years, it was the site of a weekly breakfast gathering of retired Carmel illustrators and cartoonists including Henry ("Hank") King Ketcham (1920–2001), creator of *Dennis the Menace*; Eldon Dedini (1917–2006), known for his *New Yorker* and *Playboy* cartoons; Gustavo ("Gus") Arriola (1917–2008), creator of *Gordo*; and Bill Bates, local newspaper cartoonist.

Six

RETAIL AND COMMERCIAL

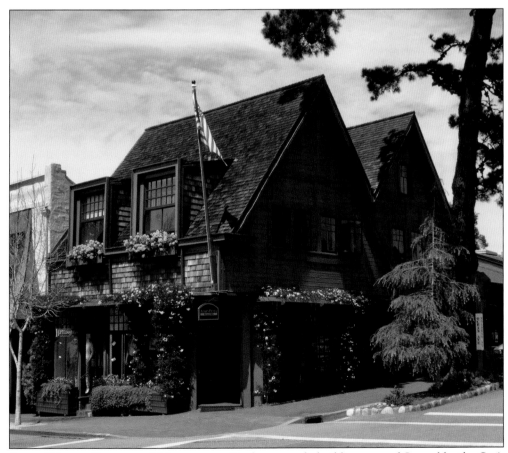

PHILIP WILSON BUILDING. This two-story Craftsman-style building, one of Carmel-by-the-Sea's oldest, was erected in 1905 on the northwest corner of Ocean Avenue and Dolores Street as a real estate office for pioneering Carmel landowner Philip Wilson Sr. (unknown–1943). Wilson's Carmel Point golf course was subdivided after World War I. The building became the town's first of three city halls, serving that function from 1917 to 1927. It remains a real estate office.

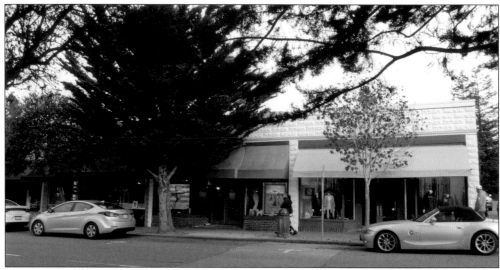

CARMEL DEVELOPMENT COMPANY BUILDING (ABOVE) AND CARMEL DRUG STORE (BELOW). The one-story building with three storefronts, one of the town's earliest commercial buildings, was constructed of fireproof concrete block in 1902–1903 on the northwest corner of Ocean Avenue and San Carlos Street. The building houses three businesses: the Carmel Development Company office (on the left), which became the Carmel Drug Store in 1910; the middle storefront began as Thomas A. Work's Hardware Store and is now a gallery; the one on the right was a grocery store until 1973, when it became the Dansk home furnishings store, remodeled by architect Olof Dahlstrand, and now a retail shop. The Carmel Drug Store interiors and facade have remained the same since the 1920s, and it still makes home deliveries.

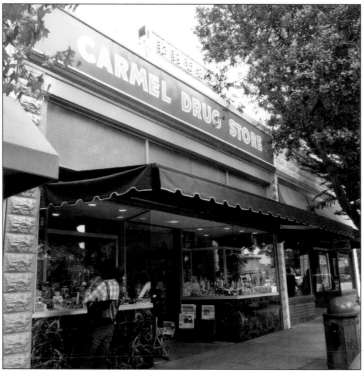

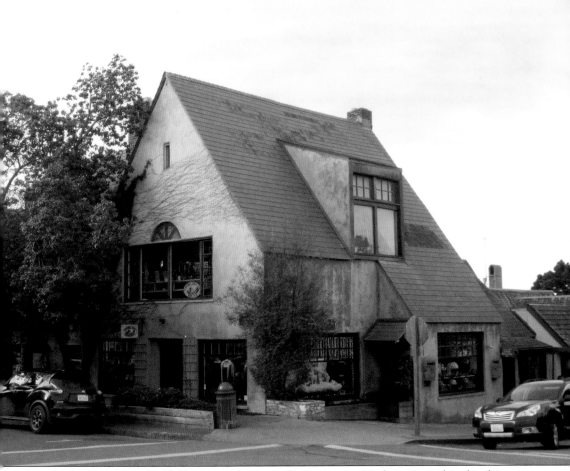

SEVEN ARTS BUILDING. In 1925, poet, thespian, and businessman Herbert Heron hired architect and artist Clay Otto and builder Percy Parkes to construct the Tudor Revival–style building on the southwest corner of Ocean Avenue and Lincoln Street. It was built with Thermotite waterproof and fireproof concrete blocks. During the 1920s and 1930s, it was home to Heron's bookshop and printing press, the Seven Arts Press; the *Carmelite* newspaper, which was modernist and focused on art, music, and culture; the Carmel Art Association's first gallery; and, later, the Carmel Art Institute, founded in 1937 by artists Armin Hansen (1886–1957) and Paul Whitman (1897–1950). Since 1972, it has been the Carmel Bay Company, an eclectic retail store featuring art and books, co-owned by Herbert Heron's granddaughter Patty Scollan.

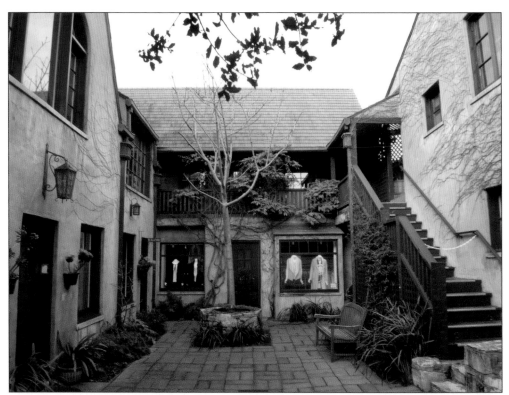

SEVEN ARTS COURTYARD. Herbert Heron also commissioned two stories of shops and offices around a courtyard with a fountain south of the Seven Arts Building on Lincoln Street. These businesses were specifically associated with the Seven Arts: music, dancing, drama, literature, painting, sculpture, and architecture.

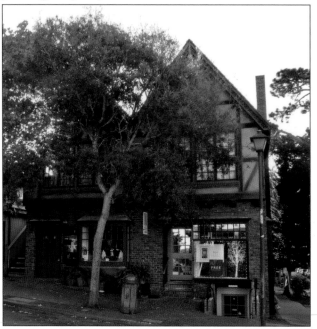

AMELIA GATES BUILDING. The San Francisco pediatrician and Carmel resident designed this two-story mixed-use commercial building resembling those she had seen in her European travels. Located on the southeast corner of Ocean Avenue and Monte Verde Street, the Medieval Revival–style building with clinker brick was built in 1928 by Fred McCrary of Pacific Grove, who oversaw construction of two buildings for San Francisco's 1915 Panama-Pacific International Exposition.

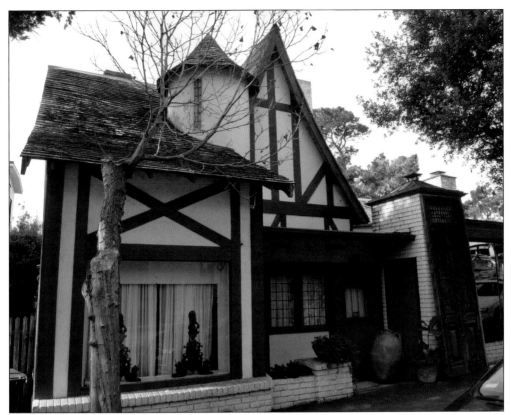

ROBERT STANTON OFFICE (ABOVE) AND N.B. FLOWER SHOP (BELOW). Starting as a contractor, Stanton built his downtown Carmel office in 1925 on Monte Verde Street 2SW of Ocean Avenue. This Tudor Revival–style building was the first part of what eventually became the Normandy Inn property. With the expansion of the hotel, Stanton designed the flower shop, now a retail store, at the southwest corner of Ocean Avenue and Monte Verde Street in the early 1950s.

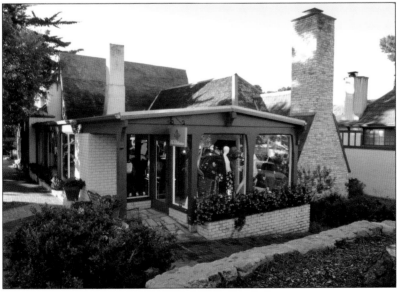

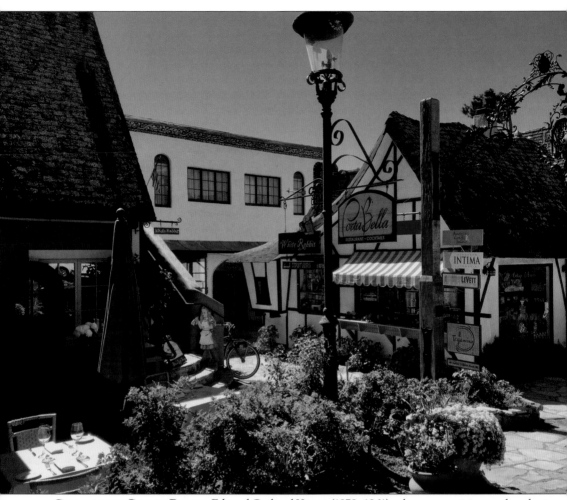

COURT OF THE GOLDEN BOUGH. Edward Gerhard Kuster (1878–1961), a lawyer, musician, and student of the theater arts and classic and medieval architecture, established the Court of the Golden Bough in downtown Carmel in the mid-1920s on the south side of Ocean Avenue between Monte Verde and Lincoln Streets. It transformed the look of the town into an Old World, medieval-style European village. The open, commercial courtyard of Carmel stone had a fountain and numerous shops. In 1924, Kuster opened an indoor theater, the Golden Bough, in the back of the courtyard; it burned down in 1935 after a performance of the play *By Candlelight*. The facade of the former theater still remains and can be seen in the background of the Court of the Golden Bough. The symbol he chose for the sign, the Golden Bough, represents the imagination. Clint Eastwood's 1971 film *Play Misty for Me*, which he produced and starred in, was filmed on the Monterey Peninsula and has a scene shot from the Court of the Golden Bough.

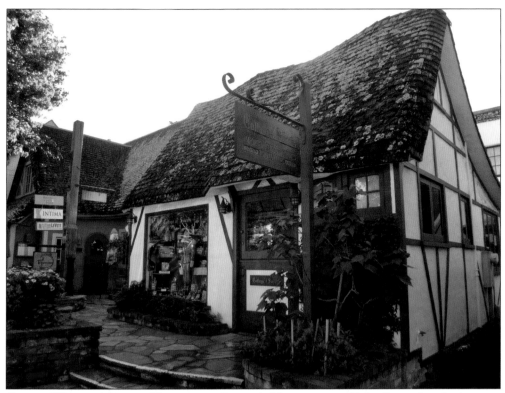

CARMEL WEAVERS' STUDIO (COTTAGE OF SWEETS). This one-story Tudor Revival–style shop was designed by Edward Kuster and constructed by Lee Gottfried in 1922 for Kuster's second wife, Ruth. It was moved in 1923 from Dolores Street and expanded on Ocean Avenue 3SE of Monte Verde Street, with a rear ticket booth, as part of the Court of the Golden Bough. It has been a candy store since 1959.

SEVEN ARTS SHOP.
In 1923, Herbert Heron commissioned this one-story Tudor Storybook–style building, which was designed by Edward Kuster and constructed by M.J. Murphy on Ocean Avenue 2SE of Monte Verde Street in the Court of the Golden Bough. In the 1930s, it was the Christian Science Reading Room, and in the 1980s, local Talbott Ties. It remains a retail shop.

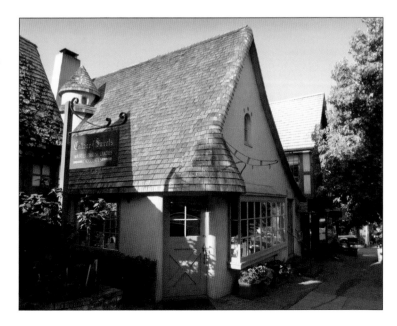

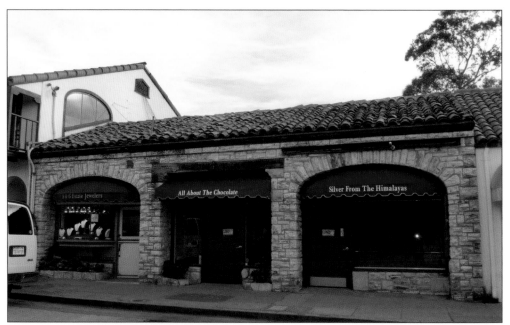

W.C. Farley Building. M.J. Murphy designed and built the one-story Spanish Eclectic–style structure with Mediterranean–Spanish Revival influence on Dolores Street 4SE of Ocean Avenue in 1927. This building housed a dry cleaner for 60 years, since it opened, and is now home to three retail shops.

Percy Parkes Building. In 1926, Carmel residential and commercial builder Percy Parkes designed, constructed, and owned the one-story Spanish Colonial Revival–style commercial building on Dolores Street 5SE of Ocean Avenue. It was a grocery store and meat market for many years and is now a retail store.

"ADAM FOX" BUILDING. This two-story mixed-use commercial building on Ocean Avenue 3SW of Mission Street, built around 1899–1910, along with the Carmel Bakery (page 66), is one of the oldest structures downtown. Both have Western false front elements, with second-story Victorian-style overhanging bay windows. A 1930s remodel added a stucco exterior and red tile roof. The ground floor contains two retail shops.

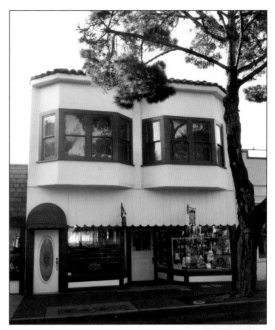

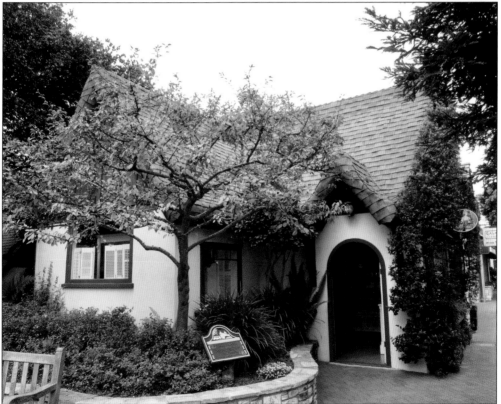

MARY DUMMAGE SHOP (2). The one-story Craftsman–Fairy Tale–style retail shop on Dolores Street 4SW of Ocean Avenue was designed and built for Mary Dummage by Percy Parkes in 1926. The store was modeled on the Tuck Box, located across the street.

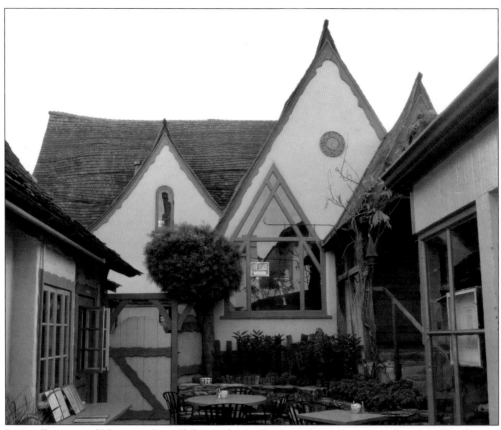

LEMOS BUILDING ("GARDEN SHOP") (ABOVE) AND GARDEN SHOP ADDITION (BELOW). The Lemos Building is in the rear portion of the Tuck Box lot on Dolores Street 2NE of Seventh Avenue. The retail shop was designed and owned by painter, teacher, and Arts and Crafts movement leader Pedro Joseph Lemos (1882–1954) in 1929. He built it in a hybrid Fairy Tale–English Craftsman style. He also designed his own house in Carmel. The Garden Shop Addition is adjacent to El Paseo building on Dolores Street 2NE of Seventh Avenue, directly south of Tuck Box. The one-story retail shop with a large bay window was owned by Lemos, and, in an Arts and Crafts–tradition collaboration, was designed by Hugh Comstock in 1931.

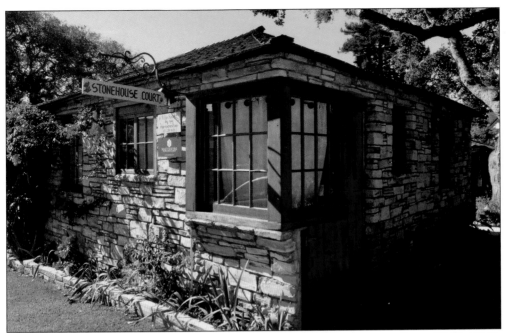

STONEHOUSE COURT. The residential-turned-commercial complex on Mission Street 5NW of Fifth was built in 1939–1941 and consists of four single-story vernacular cottages of Carmel stone, with gardens and patios. It was designed and built by master stonemason John Bathen of Norway, also a commercial fisherman and owner of Santa Lucia Quarries.

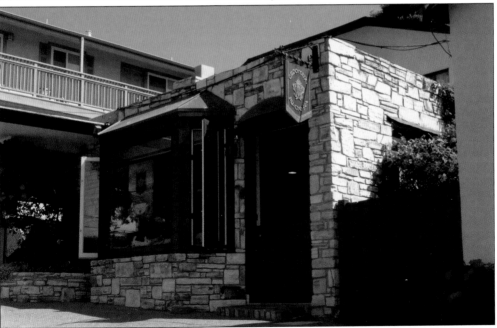

FRANK LLOYD STONE COTTAGE. Stonemason John Bathen taught newspaperman, fisherman, and homebuilder Frank Lloyd how to do masonry. Lloyd designed the vernacular Carmel stone cottage in 1940, built with Bathen's assistance, as part of a stucco apartment complex on Mission Street 3SE of Third Avenue in 1949. The residential cottage was recently converted for commercial use.

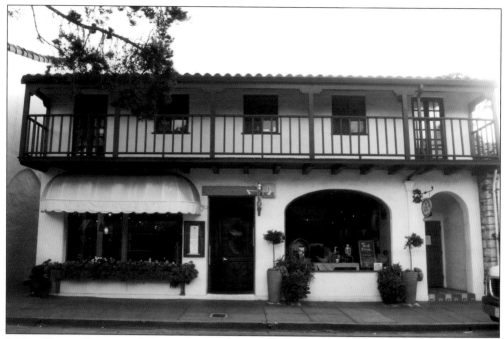

ISABEL LEIDIG BUILDING. The original building permit for the two-story commercial Spanish Revival–Monterey Colonial–style building on Dolores Street 3SE of Ocean Avenue was lost. It is speculated that Carmel's most prolific builder, M.J. Murphy, designed and constructed it in 1925. The marriage of Isabel Martin and Robert Leidig joined two early Carmel families.

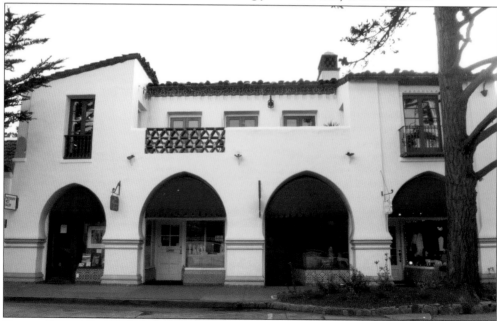

DRAPER-LEIDIG BUILDING. This large, two-story Spanish Colonial Revival–style building on Dolores Street 2SE of Ocean Avenue was constructed by builder C.H. Lawrence and designed by architects Blaine and Olson, both Oakland firms, in 1929. The ground floor is commercial and the top is residential. Isabel and Robert Leidig's daughter Jean married Raymond Draper.

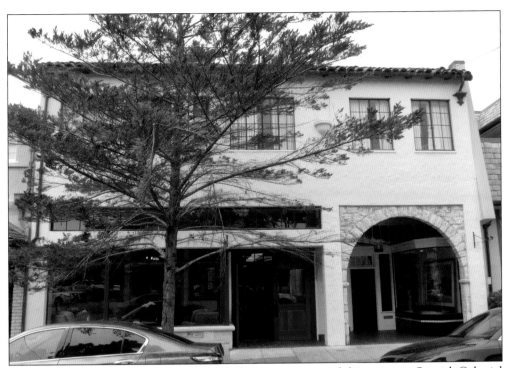

WILLIAMS BUILDING. Santa Cruz architect A.W. Story constructed this two-story Spanish Colonial Revival–style building in 1931 on Dolores Street 3SW of Seventh Avenue. It is mixed-use, with businesses on the ground floor; the upper floor is residential. Story designed Watsonville's Veterans Memorial Building in 1932.

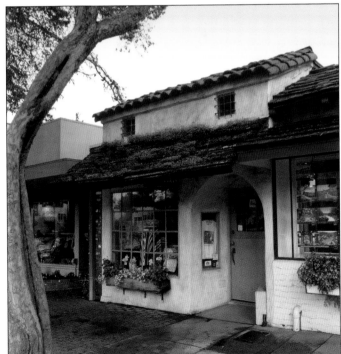

BERNARD WETZEL BUILDING. The one-and-a-half-story commercial building on Ocean Avenue 3NE of Dolores Street was once the site of a barbershop where the city's 1916 incorporation petition was signed. In 1928, businessman Bernard Wetzel commissioned English builder Frederick Bigland to design and construct the Spanish Eclectic–style building, which housed a children's clothing store for many years.

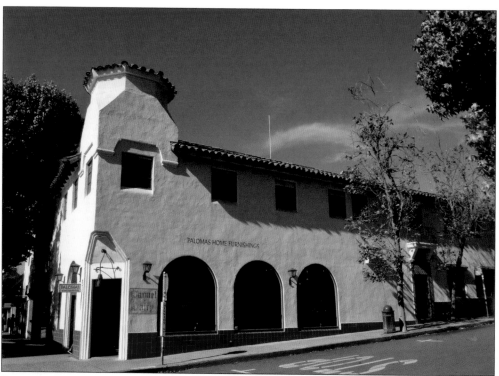

REARDON BUILDING (ABOVE) AND CARMEL DAIRY SIGN (BELOW). In 1932, plumber and pioneering civic leader Thomas B. Reardon (1874?–1932) hired Guy Koepp to design the mixed-use Spanish Eclectic–style building with a second-story, milk bottle–shaped tower on the northwest corner of Ocean Avenue and Mission Street at the heart of downtown. The builder was A. Carlyle Stoney. Carmel Dairy owner Earl Graft (1895–1970) ran the ground-floor soda fountain until the mid-1940s. He hired artist Jo Mora for interior artwork, but only the exterior sign now remains. In the 1950s, architect Francis Palms made design changes; it became Mediterranean Market, an Italian grocery store and delicatessen, for a half-century. Since 2002, it has been a home furnishings store. The second story remains residential.

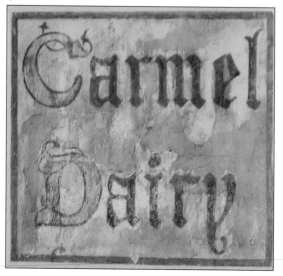

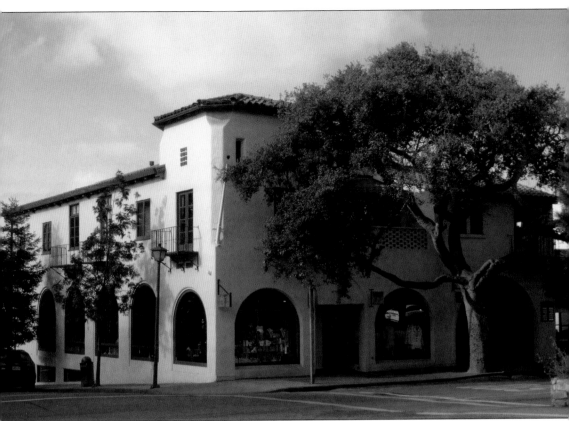

Doud Building. At the gateway to downtown on the site of the old Manzanita Club (1916–1926), this large, two-story Spanish Colonial Revival–style building on the southwest corner of Ocean Avenue and Mission Street was built opposite of and meant to mirror the Reardon Building. M.J. Murphy constructed it in 1932 for the Doud family, pioneers in local cattle ranching in the 1840s and Nevada's silver boom in the 1860s. The post office was on the ground floor in the 1930s; afterward, it became a dry-cleaning business. In 1970, it was remodeled into an Orange Julius and Swensen's Ice Cream parlor until the mid-1980s. Though altered through the years, the ground floor has remained retail space. The upstairs floor was residential; after World War II, it was converted to office space.

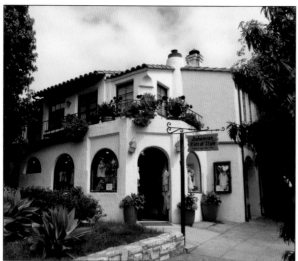

FEE BUILDING. M.J. Murphy designed and constructed this Spanish Colonial Revival–style building in 1935 on Ocean Avenue 2NE of Lincoln Street for owner William P. Fee. It continues to be a mixed-use building, with a retail shop on the first floor and an apartment on the second story.

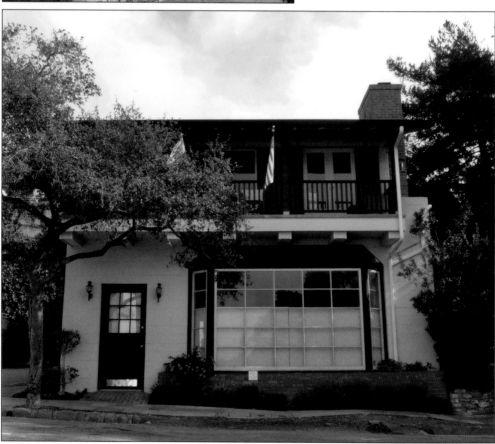

SPINNING WHEEL RESTAURANT. Bay Area architect Edwin Lewis Snyder (1887–1969), a 1940s and 1950s Carmel resident known for his Spanish Colonial Revival–style Northern California homes, designed this two-story Monterey Colonial Revival–style building in 1952 on Monte Verde Street 3NE of Seventh Avenue. The ground level was a restaurant for 30 years; the owners lived on the second floor. After the restaurant closed, the building became commercial office space.

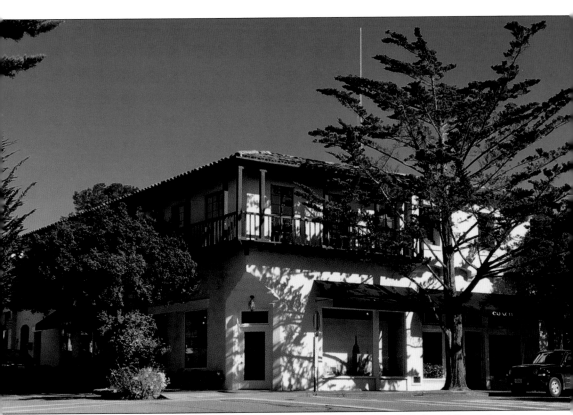

GOOLD BUILDING. In 1935, Guy Koepp designed the large, two-story Spanish Colonial Revival–style building on the northeast corner of Ocean Avenue and San Carlos Street. M.J. Murphy was the builder. This was the site where the Hotel Carmel burned down in 1931 on land owned by the family of pioneering businessman, major landholder, and civic leader Charles O. Goold (1871–1931), who had operated the horse-drawn stage and later motorized bus transporting passengers and mail from Monterey to Carmel. His widow, Mary Machado, lived on the second floor. Her father, Christiano Machado, was from a local Portuguese whaling family and Carmel Mission's longtime caretaker. The upstairs apartment became offices in 1970 and was the location of the *Carmel Pine Cone* until 2000. The lower floor is commercial and has housed the Coach store since the 1990s.

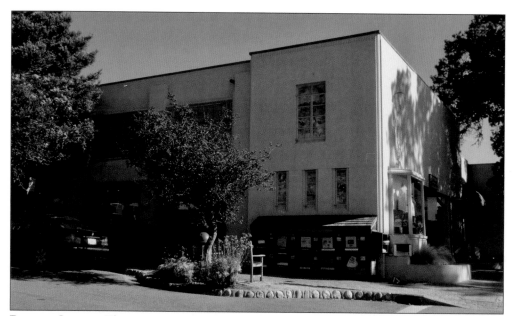

BANK OF CARMEL. The two-story building on the northeast corner of Ocean Avenue and Dolores Street is Carmel's only Art Deco Moderne–style structure. Designed in 1938 by architect C.J. Ryland and built by Pacific Grove contractor W.P. Sweeney, it remained a bank until 1972, when it was altered to become a retail establishment. The two bas-relief sculptures of Fr. Junípero Serra on the upper facade are by artist Paul Whitman.

CARMEL DRIVE-IN MARKET. Opened in 1940 at the northeast corner of Dolores Street and Eighth Avenue, the grocery was in business for a half-century. Through the years, there were as many as a half-dozen grocery stores in town—now, two remain. It was recently remodeled into commercial office space.

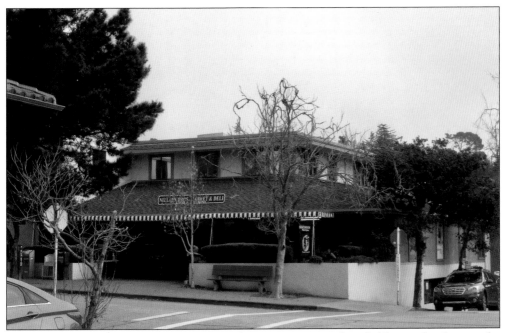

NIELSEN BROS. MARKET. This longtime family-run grocery was founded by two brothers in the 1930s and sold in 2009. In the mid-1980s, it was moved to this new building constructed on the northeast corner of San Carlos Street and Seventh Avenue, the site of a former gas station.

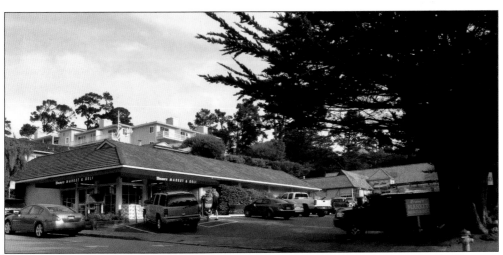

BRUNO'S MARKET AND DELI. This grocery began in 1953 and has been in business at this location on the northeast corner of Junipero Street and Sixth Avenue since 1973. The market is known for its deli sandwiches and barbecue and makes home deliveries.

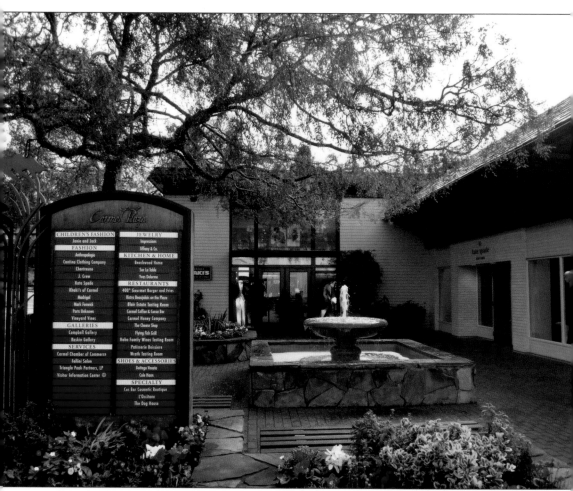

CARMEL PLAZA. This three-level shopping center covers the entire city block bounded by Ocean Avenue, Seventh Avenue, Junipero Street, and Mission Street. In the late 1950s, British-born Hollywood actor and director Leslie C. Fenton (1902–1978) purchased the block for the development, which was controversial because of its size, that underwent many design revisions before opening in 1960. Initial plans were by local architect Francis Palms with San Francisco architectural firm Skidmore, Owings & Merrill. Later designs were by architect Olof Dahlstrand, who became a Carmel resident. The Carmel Theater, designed by renowned San Francisco architect A.A. Cantin (1874–1964) and located on the southeast corner of Ocean Avenue and Mission Street from 1936 to 1959, was demolished to make way for Bank of America, now Tiffany & Co. The retail tenants, ownership, and storefront appearances have changed through the years. The longtime anchor tenant on the southwest corner of Ocean Avenue and Junipero Street was luxury clothing retailer I. Magnin until 1994, when Saks Fifth Avenue took over for a decade; it was replaced by San Francisco high-end haberdasher Wilkes Bashford until 2009 and is currently home to Khaki's Men's Clothier.

WELLS FARGO BANK. In 1964, architect Olof Dahlstrand designed this building on San Carlos Street 2SE of Ocean Avenue. Its design elements are reminiscent of Frank Lloyd Wright's Prairie and Organic architecture, such as the roof with wide overhanging eaves and textured concrete walls.

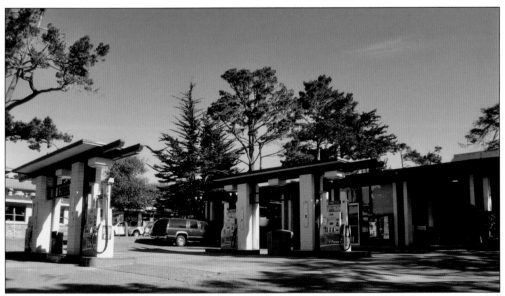

SHELL GAS STATION. Only one of two remaining gas stations in Carmel-by-the-Sea, the Shell is located on the southeast corner of San Carlos Street and Fifth Avenue. Designed by architect Will Shaw of Burde, Shaw, and Associates in 1964 in an "industrial version" of the Second Bay Region style, it received an architectural award in 1966.

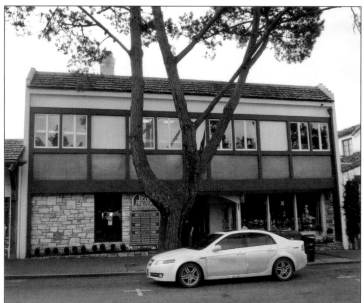

DOUD ARCADE. The two-story commercial building with shops and restaurants on the ground floor and offices on the second floor was constructed on Ocean Avenue 2SW of San Carlos Street in 1961 for businessman and real estate developer James C. Doud. The arcade connects with Doud Craft Studios (see page 45) and was home to longtime casual Italian restaurant Paolina's.

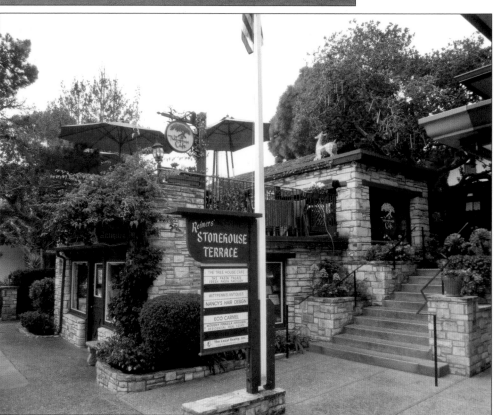

REIMERS' STONEHOUSE TERRACE. Architect Olof Dahlstrand designed the Carmel stone shopping plaza terrace in 1977 on San Carlos Street 2SW of Seventh Avenue for the Reimer family. It is centered around what had been their former home since 1937, now a store and part of the mixed-use commercial plaza with retail shops and an outdoor-seating restaurant.

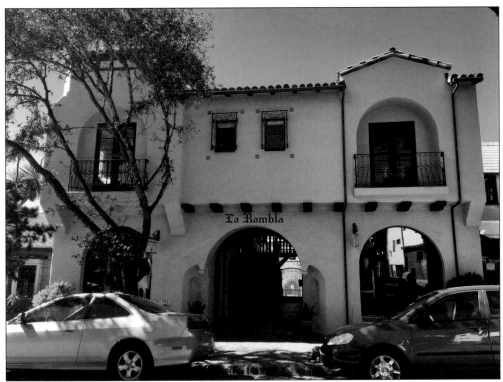

LA RAMBLA (ABOVE) AND PASSAGEWAY (BELOW). The two-story Spanish Eclectic–style commercial building with a central-arcaded tile passageway is located on Lincoln Street 2SW of Ocean Avenue. Guy Koepp designed it and Carlyle Stoney built it in 1929 for Josephine Baber. Koepp designed many residences and commercial buildings in Carmel in the 1920s and 1930s. La Rambla has shops on the ground floor and two apartments on the second floor. The arched arcade leads to a lower courtyard, which was home to a longtime outdoor garden shop, Aslan's Garden, but is now private. The building underwent a major renovation in 2014–2017.

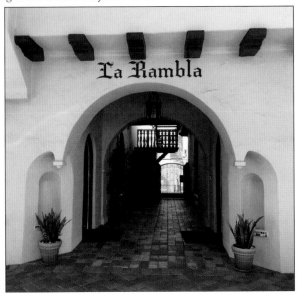

LAS TIENDAS (ABOVE) AND PASSAGEWAY (BELOW). Realtor, businessman, state assemblyman, major landholder, and civic leader Ray de Yoe commissioned the large, two-story building on Ocean Avenue 3SW of San Carlos Street in 1930. The Spanish Eclectic–style commercial building's passageway leads to a central interior courtyard, which has been a coffeehouse patio since 1994. There are shops on the ground floor and offices upstairs. Las Tiendas was designed by Monterey- and Fresno-based architects Fred Swartz and C.J. Ryland and constructed by M.J. Murphy with reinforced concrete. The architectural details include wrought ironwork, colorful Spanish tile, and a red tile corridor.

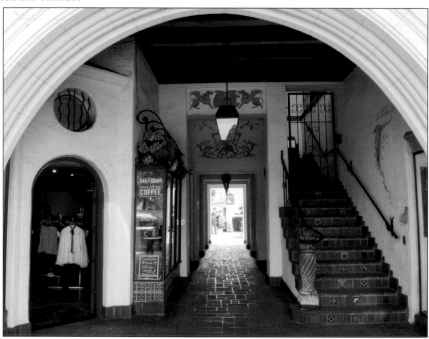

PILGRIM'S WAY AND SECRET GARDEN. Carmel-by-the-Sea was founded as an artists' and writers' colony, yet this is the last remaining bookstore in town. The independent eclectic bookshop, open since 1969, is on Dolores Street 5NE of Sixth Avenue. The outdoor Secret Garden, with a fountain, is located at the end of a narrow bamboo-lined passageway and sells figurines and plants.

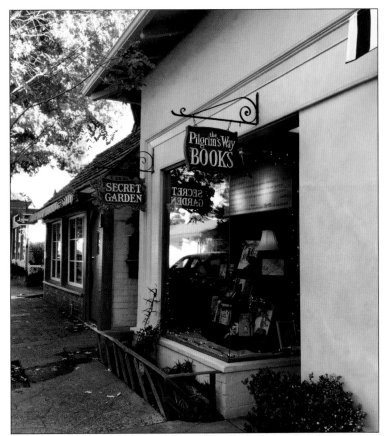

EASTWOOD BUILDING. Renowned local modernist architect George Brook-Kothlow (1934–2012) designed the large, redwood, two-story commercial building for Clint Eastwood in 1988 on San Carlos Street 3SW of Fifth Avenue. The construction permit battle for this building, located next to Hog's Breath Inn, was the principal reason why Eastwood ran for mayor in 1986.

Discover Thousands of Local History Books Featuring Millions of Vintage Images

Arcadia Publishing, the leading local history publisher in the United States, is committed to making history accessible and meaningful through publishing books that celebrate and preserve the heritage of America's people and places.

Find more books like this at
www.arcadiapublishing.com

Search for your hometown history, your old stomping grounds, and even your favorite sports team.

Consistent with our mission to preserve history on a local level, this book was printed in South Carolina on American-made paper and manufactured entirely in the United States. Products carrying the accredited Forest Stewardship Council (FSC) label are printed on 100 percent FSC-certified paper.

MADE IN THE USA